David and Charles

"Pop art is a way of liking things." Andy Warhol

Pop Art

text MARTINA ANGELOTTI

with VALENTINA CIUFFI and VERONICA LENZA

project editor VALERIA MANFERTO DE FABIANIS
editorial coordination FEDERICA ROMAGNOLI
graphic design MARINELLA DEBERNARDI

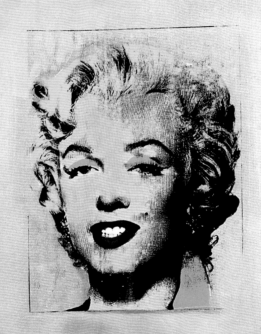

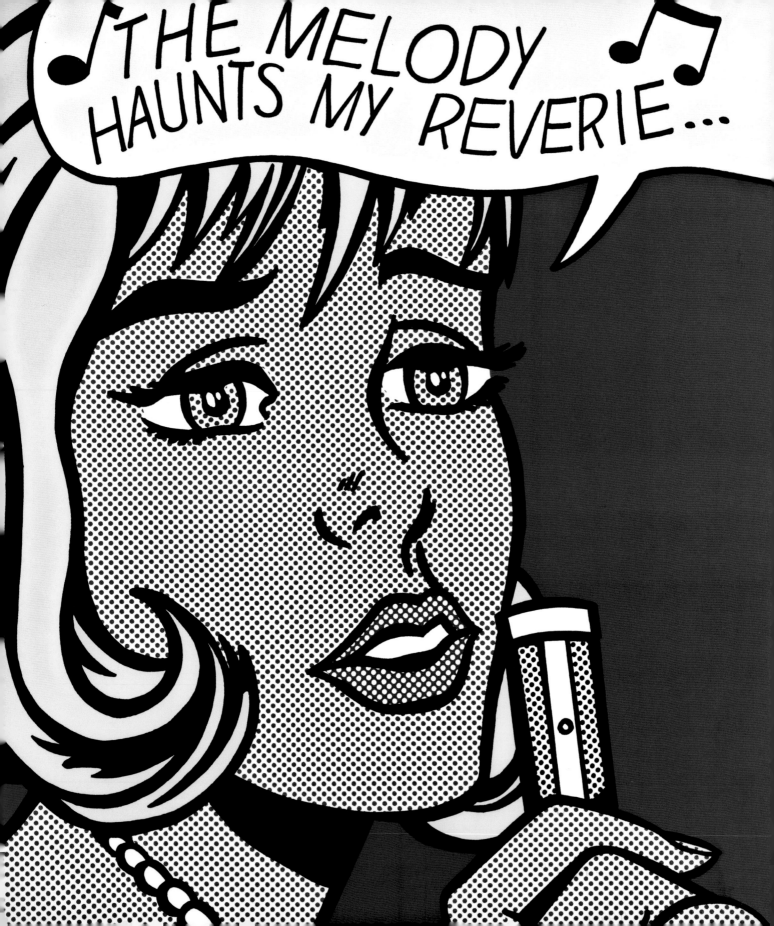

Con/tents

introduction

Why publish an illustrations and text volume on Pop Art? The best answer is because Pop Art remain an important force in the wider world of art. Pop Art therefore undisputably deserves an attractive and significant volume presenting its history – that of a unique period. Strongly influenced by different sectors of culture, such as sociology and philosophy, Pop Art brought about an abrupt break from the previous artistic tradition, a break that even today is of great interest. Through a careful selection of artists and images, together with a concise explanatory narrative, we are attempting to present the most significant highlights and examples of a vast and rich period that still resonates in the artistic imagination. Talking about "Popular Art," from which the abbreviation "Pop Art" derives, means talking about a trend that followed significant preceding movements, like American Abstract Expressionism, New Dadaism, the French Nouveau Réalism, hailed by a small circle of intellectuals who in turn adopted the suggestions and teachings of "the Master of Masters": Marcel Duchamp.

With Pop Art, which first appeared in the United Kingdom, but which really came into its own in the United States, the very concept of the work of art is questioned. In the era of technical reproduction, as the German philosopher Walter Benjamin wrote in 1936, the work of art had lost its

"aura," the very quality which made it eternal, absolute, unique and unrepeatable.

From the early Forties onward, with the explosion of the new mass media, Hollywood cinema, comic strips, and popular literature, there were not only new cultural codes and products, but a different way of enjoying an aesthetic experience. From this stems the distinction between high culture and low culture which philosophers of the Frankfurt School, predominantly Max Horkheimer and Theodor Adorno, had started to examine, without concealing their own pessimism. The breach created by Pop Art resulted in a new way of conceiving a work of art, like a simple language of reality without any aesthetic or sentimental meanings.

The real innovation, therefore, consists in adopting the same language codes as those of advertising and modern reproduction techniques to extract a figurative object and subsequently to transfer it into a context of cultured art, thereby associating with it a new semantic order and, in some way, giving it back its lost aura.

It is not by chance that many Pop artists moved to art after maturing in a working experience in other professions. Andy Warhol began as a graphic designer in advertising, Roy Lichtenstein as a cartoonist, James Rosenquist as a billboard painter, while many of the English Pop artists had working-class origins.

All this, on the one hand, meant developing a rapport with the specific techniques and languages of popular culture, and, on the other, a feeling of repossession and re-assertion of the materials and imagination of popular culture.

Mass culture, which is intimately linked to the notion of entertainment, was produced through the obsessive reproduction of clichés and was consumed as merchandise rather than assimilated. The artificiality of the colors, the plastics, the compressed air balloons, and the objects drawn from daily life such as tinned food and bottled drinks, are some of the objects which Pop Art literally "stages," removing them from their original context to give them an artistic dimension.

Although this Pop Art volume is arranged in geographic order, it begins with Andy Warhol, in recognition of the position and importance he held within this movement.

Indeed, Warhol – as well as being one of its most authentic exponents – is the artist who brought Pop Art its great notoriety. In addition, he personally exercised considerable influence in all areas of culture.

The body of the book is arranged on a geographic basis, starting with the United States and moving to the United Kingdom, where the critic Lawrence Alloway spoke for the first time of "pop culture," referring however, not to real works of art but to mass culture products, in keeping with the philosophy of the Independent Group, a group of artists prominent at the time.

The third part of the work is about Italy in the Sixties when, in the unique political and social climate of the time, very interesting work was produced in the artistic and creative spheres. It has not been possible to include all Pop artists, and if some expected artists have not been featured, it is due to the constraints of time, size and production needs.

The book's many images and direct narrative explain Pop Art – one of the 20th century's most renowned artistic trends – in accessible terms by presenting the key practitioners together with the originality of their work and the idiosyncrasies of their lives, captured in the brief biographies that accompany them.

5 Gold Marilyn Monroe, 1962
Museum of Modern Art (MoMa), New York
Silkscreen ink on synthetic polymer paint on canvas - 211.4 x 144.7 cm.

6 Roy Lichtenstein, Reverie, 1965
Museum of Modern Art (MoMa), New York - Screenprint - 68.9 x 58.3 cm.

13 Jasper Johns, Figure 8, 1959
Ileana and Michael Sonnabend Collection, New York
Encaustic on canvas - 51 x 38 cm.

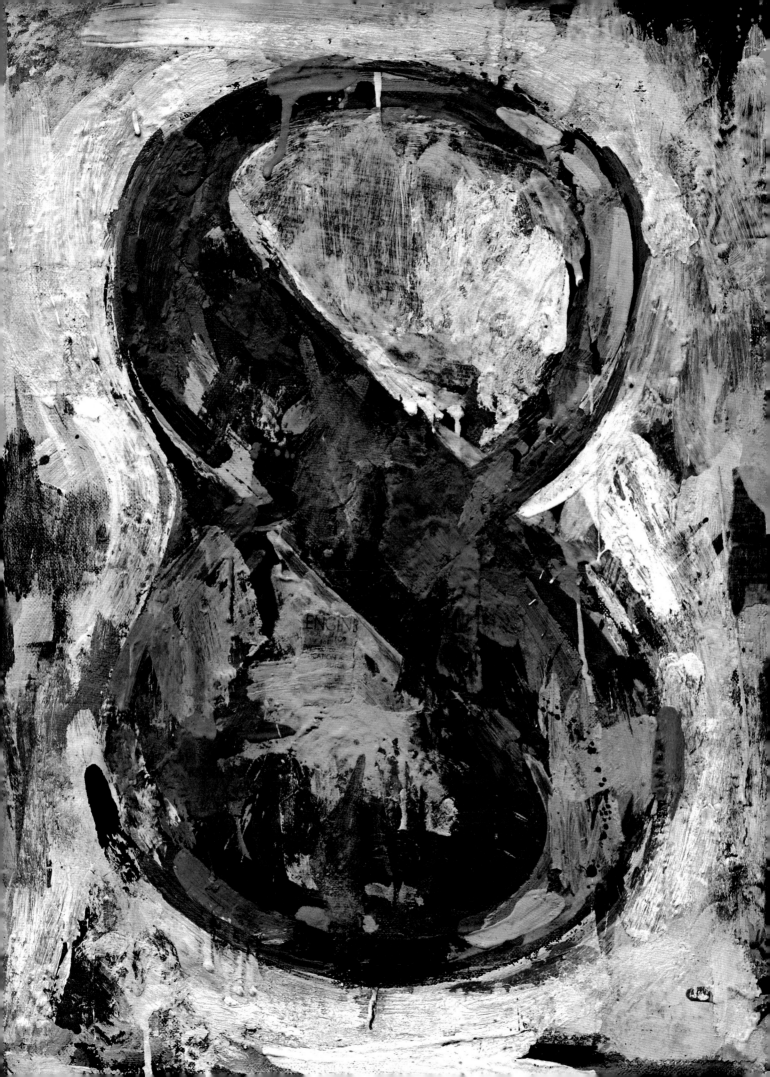

"I have Social Disease.
I have to go out every night.
If I stay home one night I start
spreading rumors to my dogs.
Once I stayed home for a week
and my dogs had a nervous breakdown."

Andy Warhol

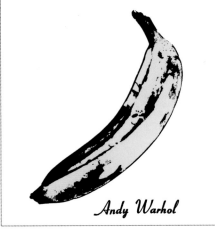

Andy Warhol

In 1967, Verve Records released *Velvet Underground and Nico*, also known as 'the banana,' due to the cover designed by Andy Warhol. The record, which in the 80s went on to become an album on which generations of musicians were formed, was recorded in a little box room in New York and was partly financed by the American artist. David Bowie, on the other hand, in the famous 'Andy Warhol,' would describe to us, some years later, a funny, bizarre Warhol, absolutely faithful to the image which the news, cinema, literature and hundreds of tales, gossip and unconfirmed reports have provided over time. Warhol arrived in New York from Pittsburgh in 1949, escaping from an over-protective and interfering mother. In New York, little by little, Warhol made his entry into the art world, after having been treated condescendingly by the managers of the most important galleries of the time, including Leo Castelli. At the time when Marcel Duchamp, who had reached the end of his career, decided to retire, Andy Warhol became famous as a result of the foundation of The Factory, a sort of laboratory, where art, cinema and music were produced indiscriminately and where art, culture, business and worldly pleasures mingled, with an approach which would leave a very profound mark on American culture. Indeed, the most eccentric characters in New York would come to The Factory, a melting pot of artists, rock stars, eccen-

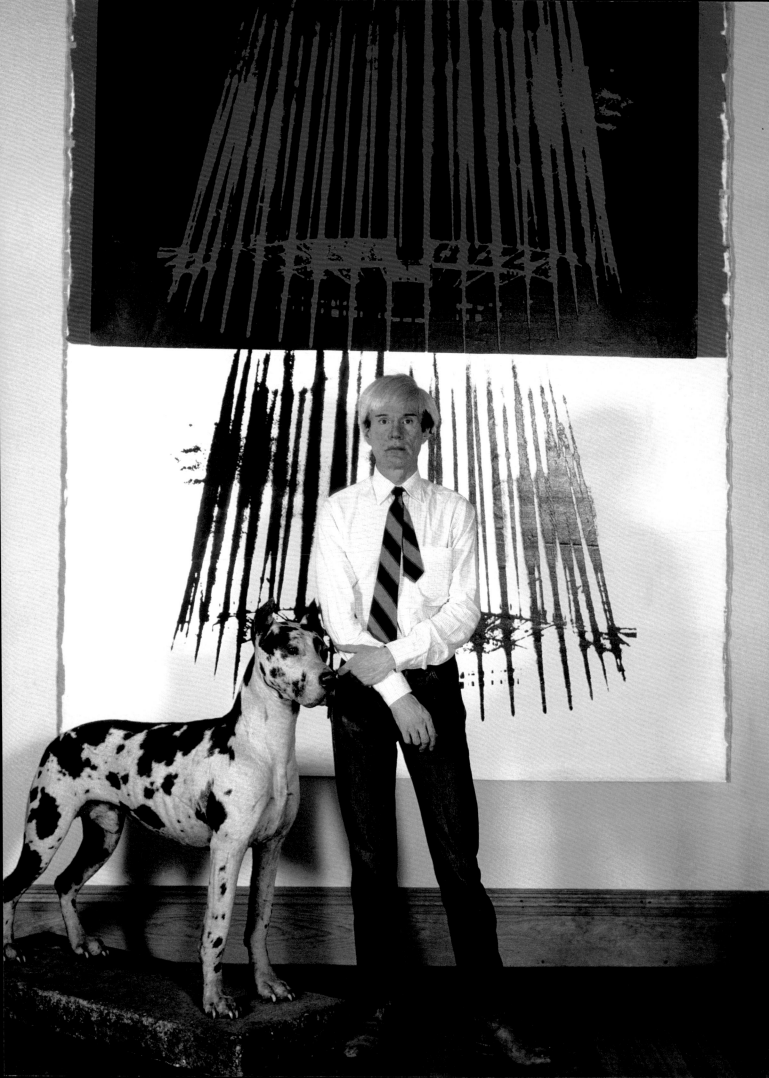

tric millionaires, junkies, international aristocracy and members of the fashion and publishing worlds.

The Warhol period was cynical, dehumanized and indifferent to the great scandals that shook American society at that time. *Death and Disaster*, a sort of disenchanted diary of images, narrated the country's catastrophes depicting through use of the technique of serigraphy such things as electric chairs, car, plane and train accidents. Warhol is in the position of the television spectator who, in the face of death, is annoyed in very much the same way as with a disturbance which breaks the uninterrupted rhythm of images.

The first work which secured his fame is the series dedicated to *Campbell Soup* (1962), displayed both on its own, with its original white and red colors, as well as multiplied on the same canvas with brighter colors, vaguely Fauviste. Using the same obsessively repetitive technique, Warhol produced a pictorial series dedicated to *Brillo*, *Del Monte* and *Heinz* packaging. But the work which truly made Warhol and made him enormously popular, which surpassed the boundaries of Art, are the series, the so-called multiples.

The multiples are dedicated to the global icons of the 20th century: Liz Taylor, Marilyn Monroe, Elvis Presley, Jacqueline Kennedy, Mao Zedong, Mick Jagger.

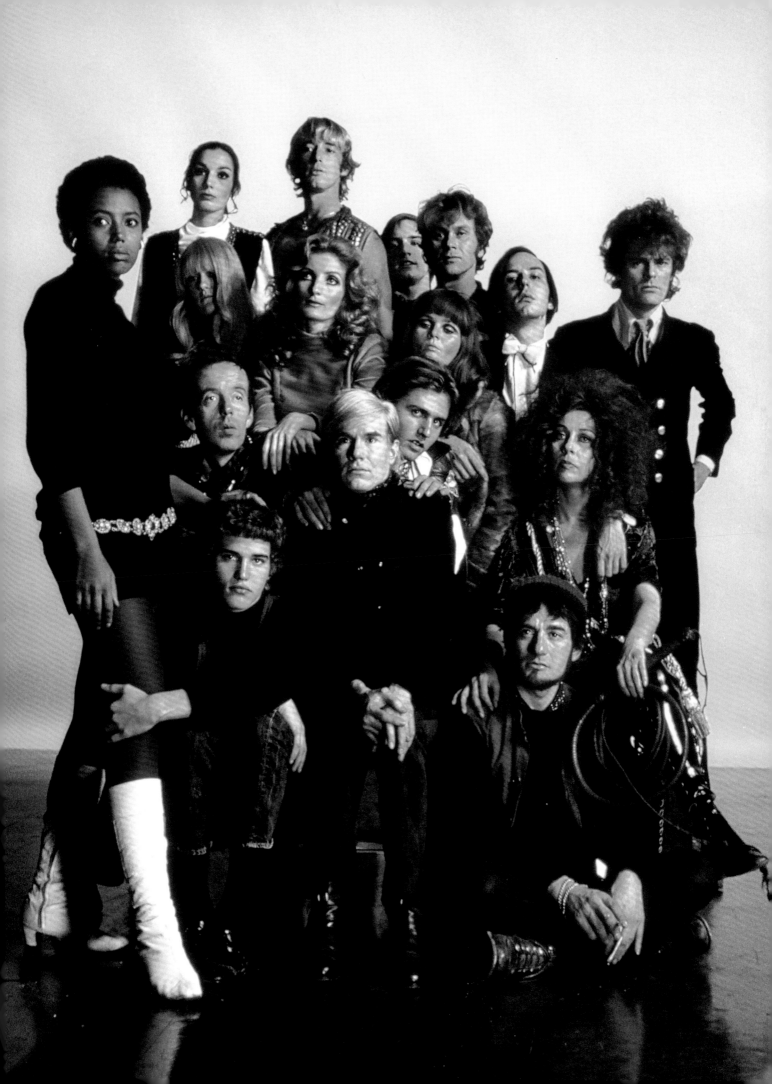

17 Andy Warhol was born in
Pittsburgh on 6 August 1928 and
died in New York on 22 February
1987.

19 The Factory Group around their
leader in a picture in 1968.

20-21 The artist photographed
at The Factory in 1966.

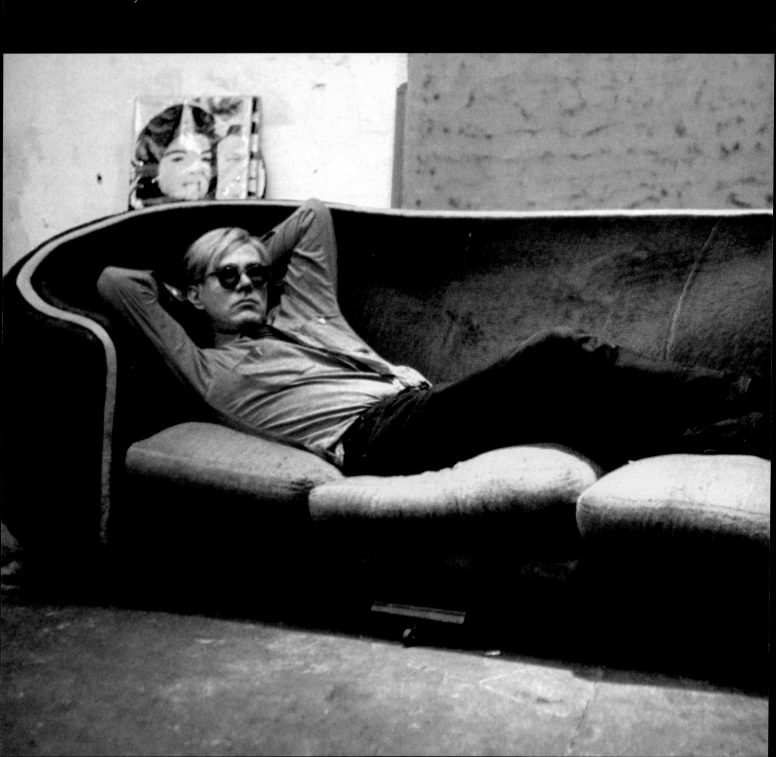

The multiple portrait by Warhol subsequently became a sort of must-have status symbol for the international jet set of the 70s and 80s.

Warhol, having elevated merchandise to the status of an artistic product and having understood the mechanism which governs circulation of the images in the media, was the true interpreter and prophet of show business society, as we know it today. His research was so coherent that his personality and his very existence were turned out like a work of art and, consequently, a commodity. It is said that he was a very kind, gentle man with a subtle, indescribable sense of humor.

His fame, even through the gossip columns, has gone beyond the limits of the Art world. His influence was considerable and even today it is impossible to look at a can of Campbell's soup without thinking of Andy Warhol.

He miraculously survived a gunshot wound, only to die as a result of a routine gall-bladder operation.

He once said: "I would like a blank tombstone. No epitaph, and no name. Well, actually, I would like it to say 'figment'."

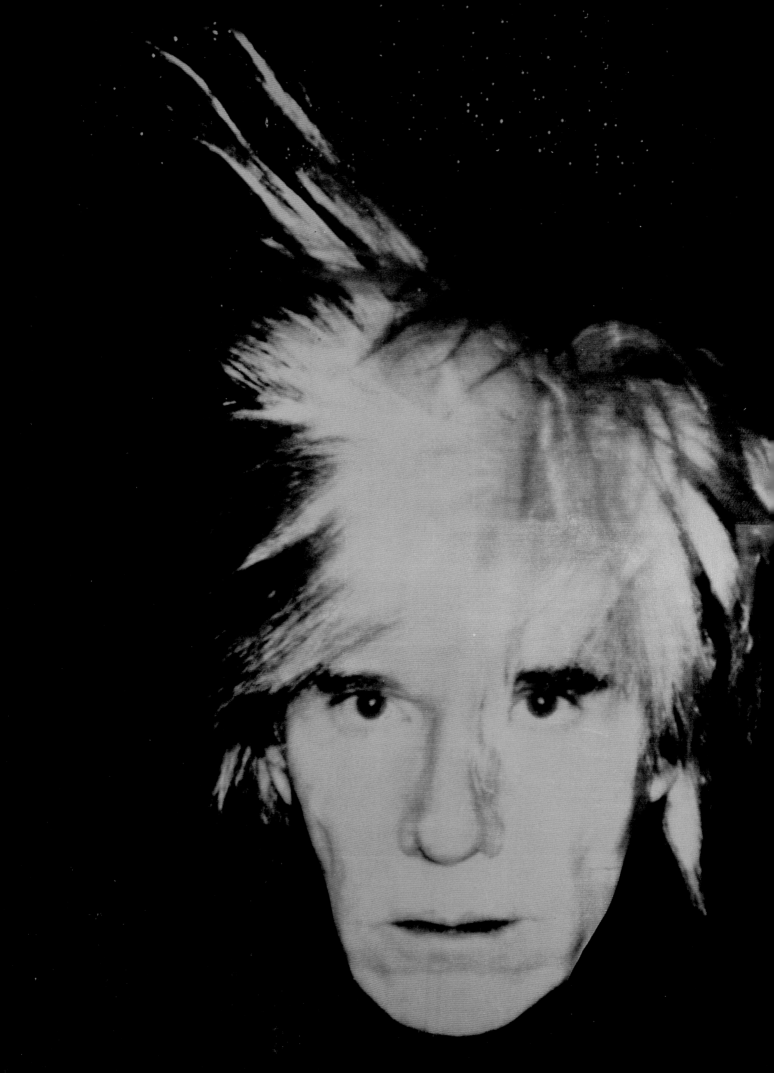

SELF PORTRAIT, 1986

Museum of Fine Arts, Houston - Acrylic screenprint on canvas - 270 x 270 cm

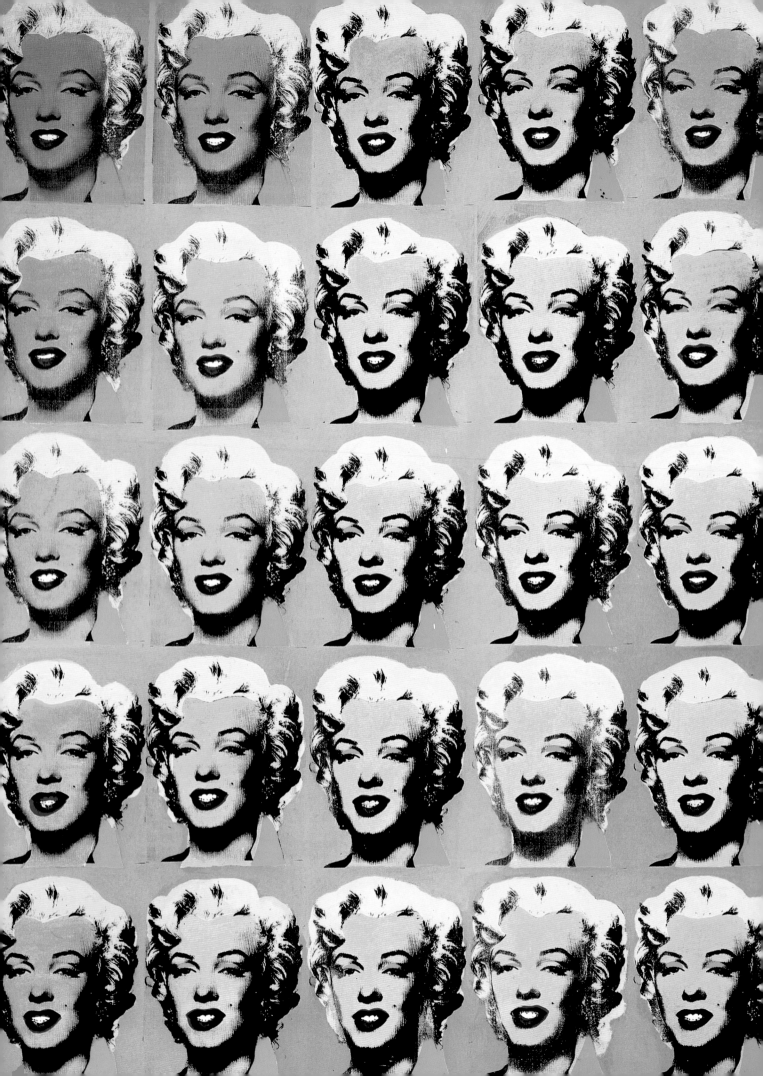

MARILYN DIPTYCH, 1962 (DETAIL)
Tate Gallery, London
Acrylic on canvas - 205.4 x 144.8 cm

SINGLE ELVIS, 1964

Ludwig Museum of Contemporary Art, Budapest
Silver painting and silkscreen on canvas - 210 x 107 cm

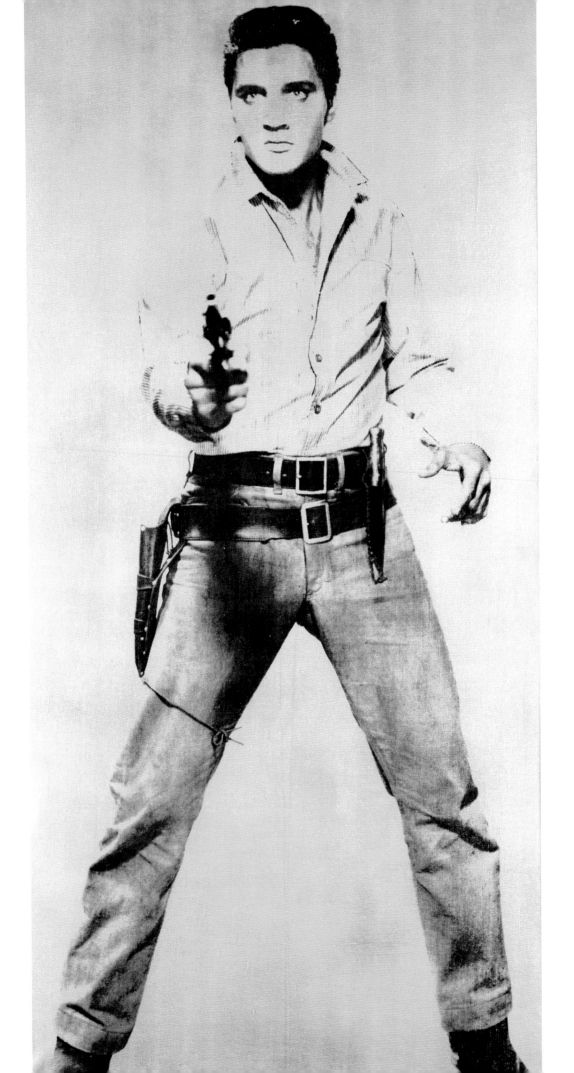

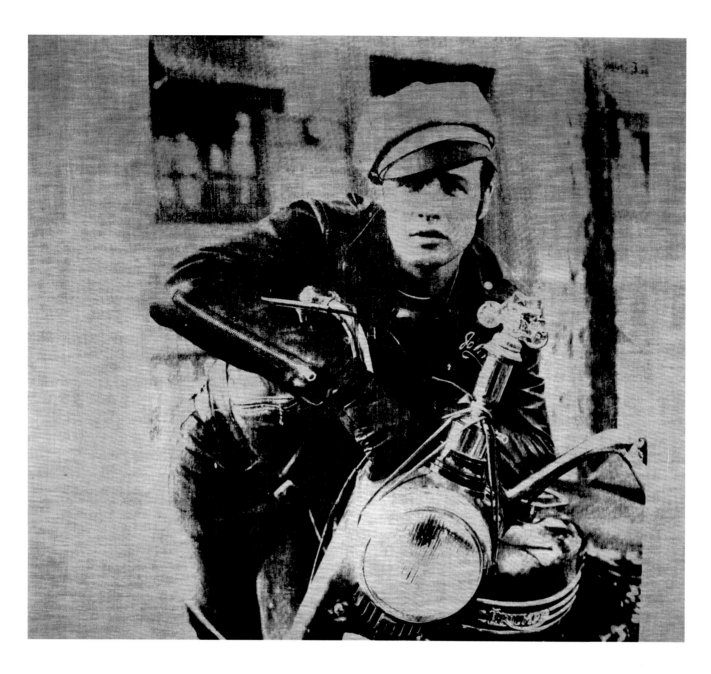

MARLON, 1966

Tate Gallery, London - Silkscreen ink on linen - 104.1 x 116.8 cm

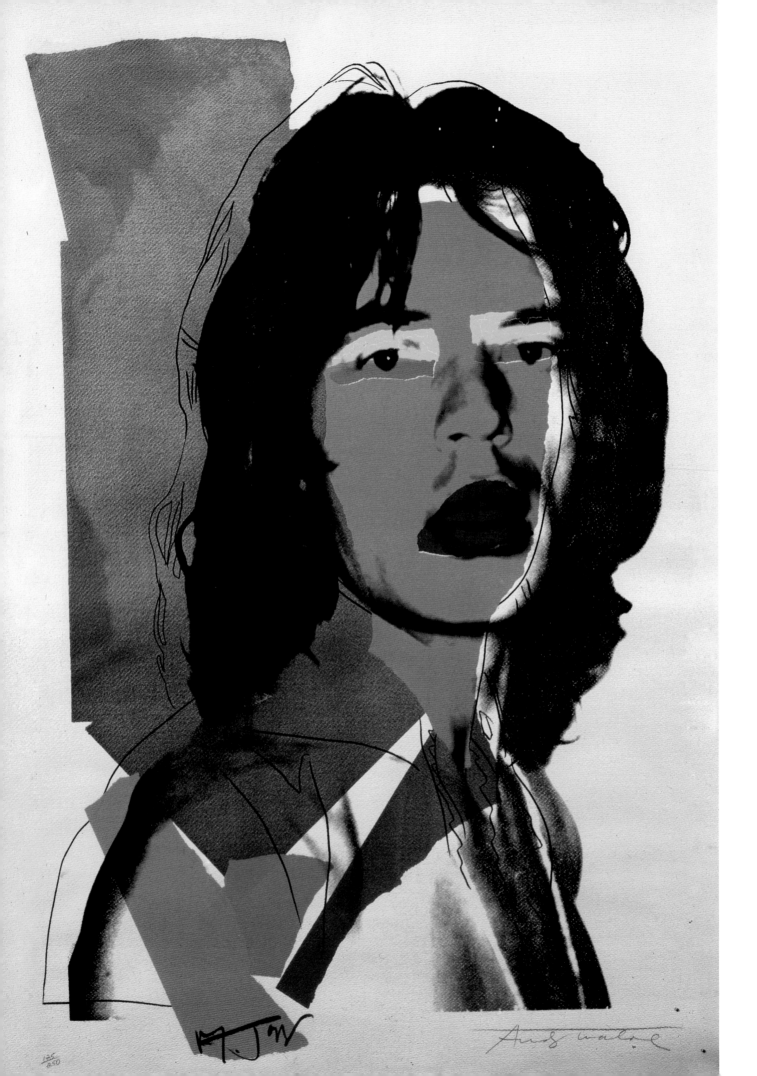

MICK JAGGER, 1975

Christie's, London - Screenprint in colors on paper - 110.5 x 73.6 cm

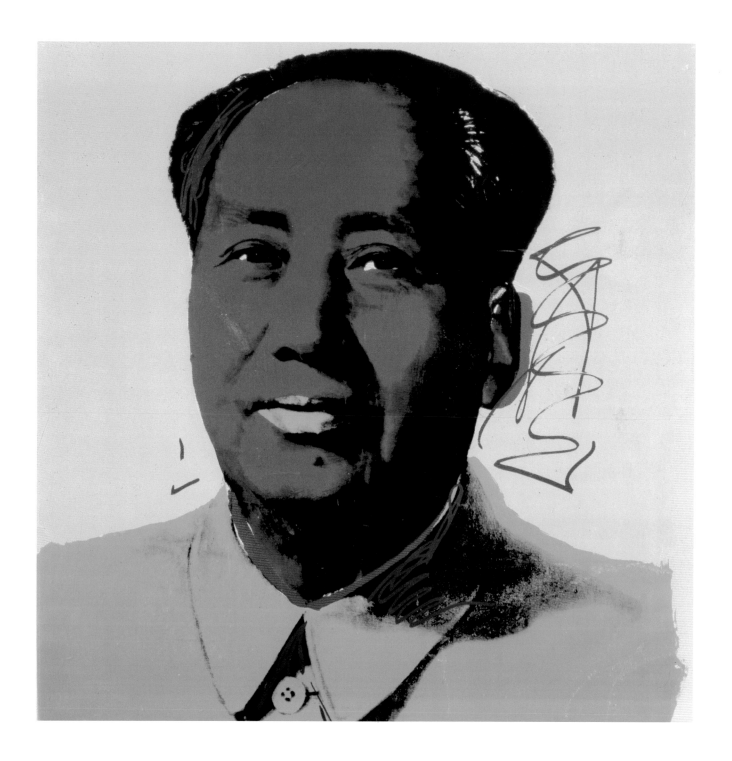

MAO TSE TUNG, 1972

Private Collection - Silkscreen on paper - 36 x 36 cm

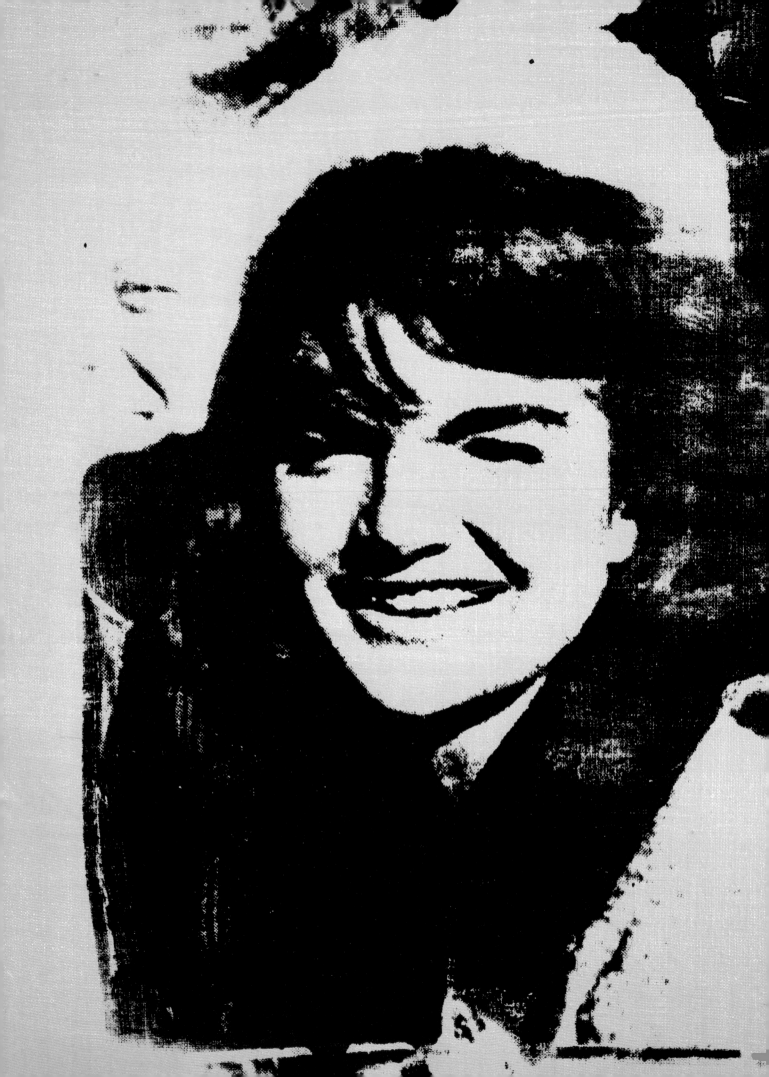

JACKIE, 1964

The Andy Warhol Foundation for the Visual Arts, Inc., New York
Acrylic and silkscreen on linen - 50.8 x 40.6 cm

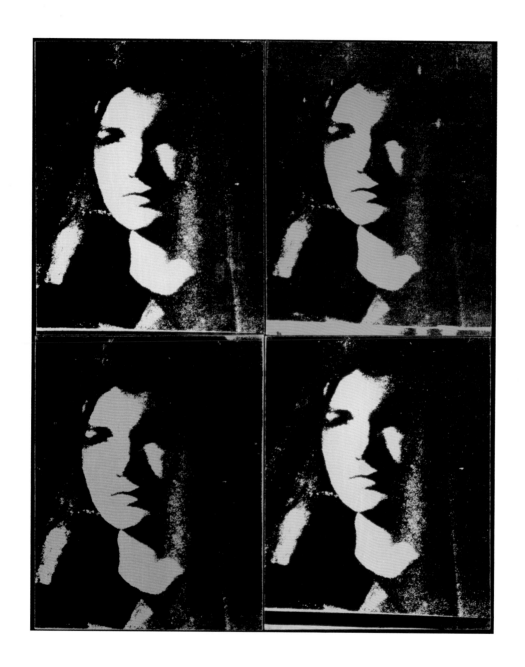

VIERMAL JACKIE, 1965

Christie's, London - Polymer and silkscreen on canvas - 50.9 x 40.6 cm

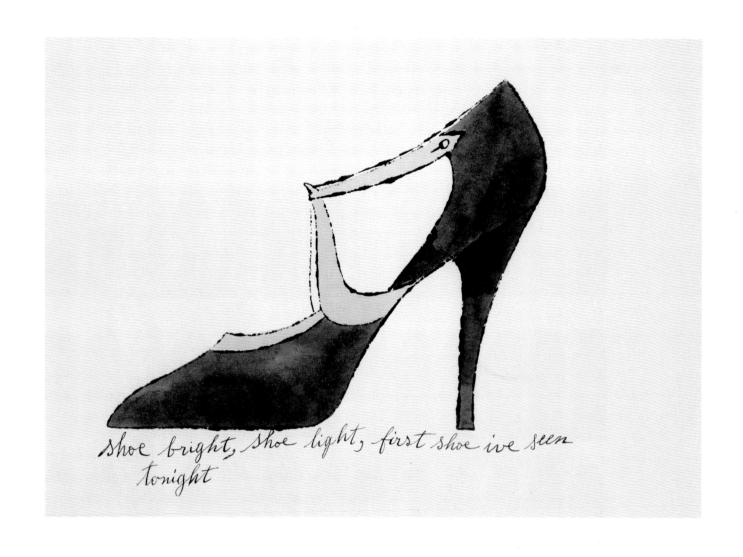

shoe bright, shoe light, first shoe ive seen tonight

SHOE BRIGHT, SHOE LIGHT, FIRST SHOE I'VE SEEN TONIGHT, 1955

The Andy Warhol Foundation for the Visual Arts, Inc., New York
Offset lithograph and Dr. Martins Aniline dye on paper 24.8 x 34.9 cm

210 COCA COLA BOTTLES, 1962

Harry N. Abrams Family Collection, New York - Acrylic silkscreen and pencil on canvas - 210 x 267 cm

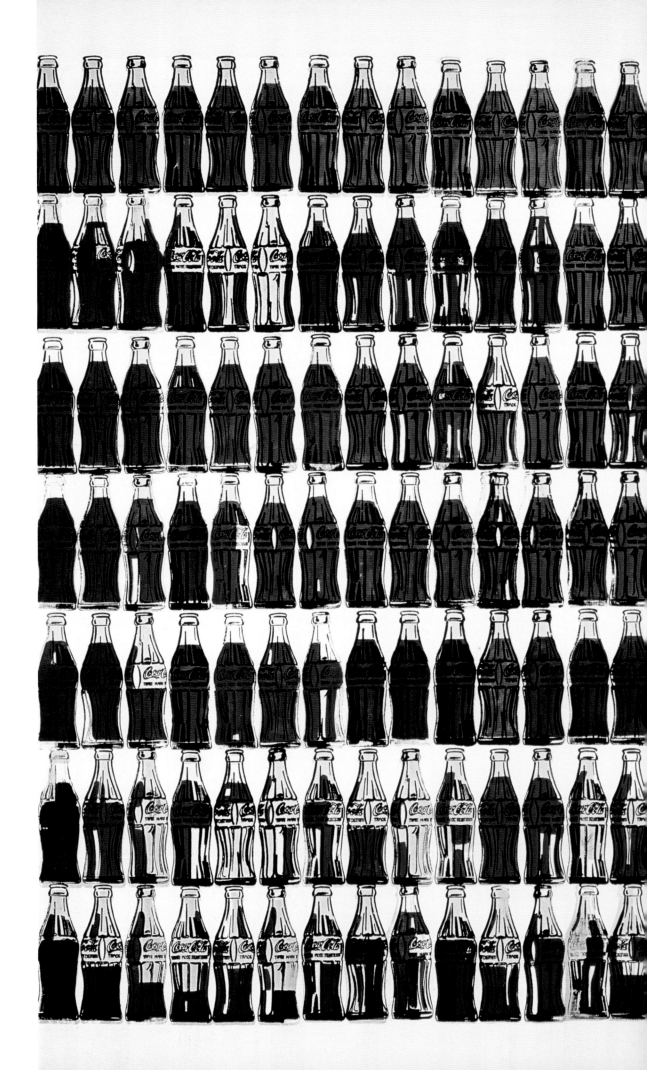

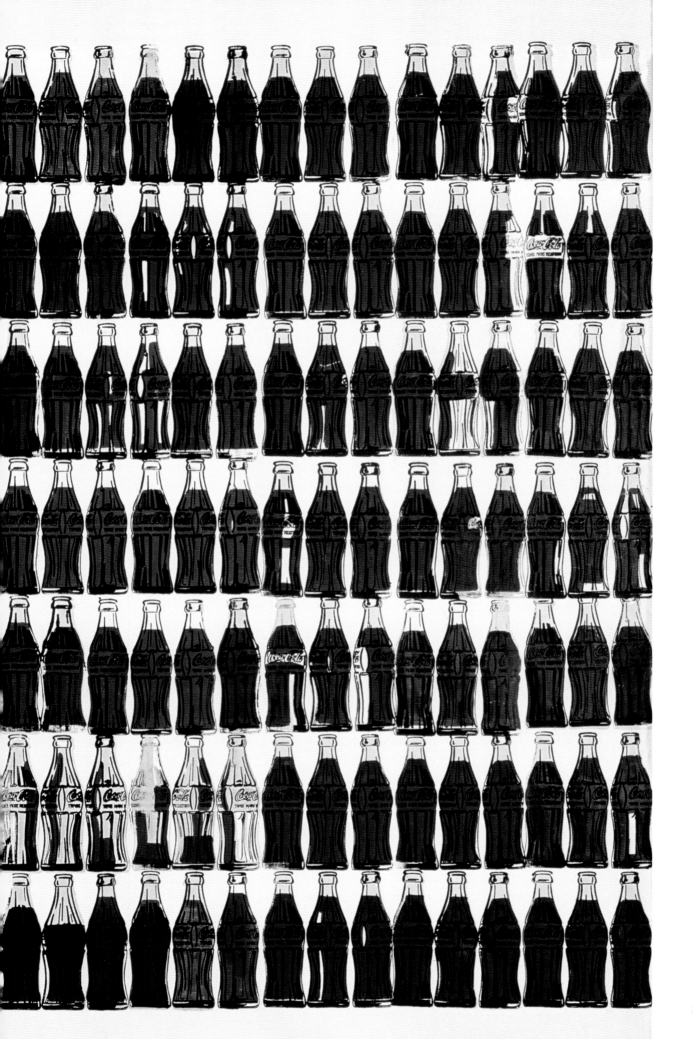

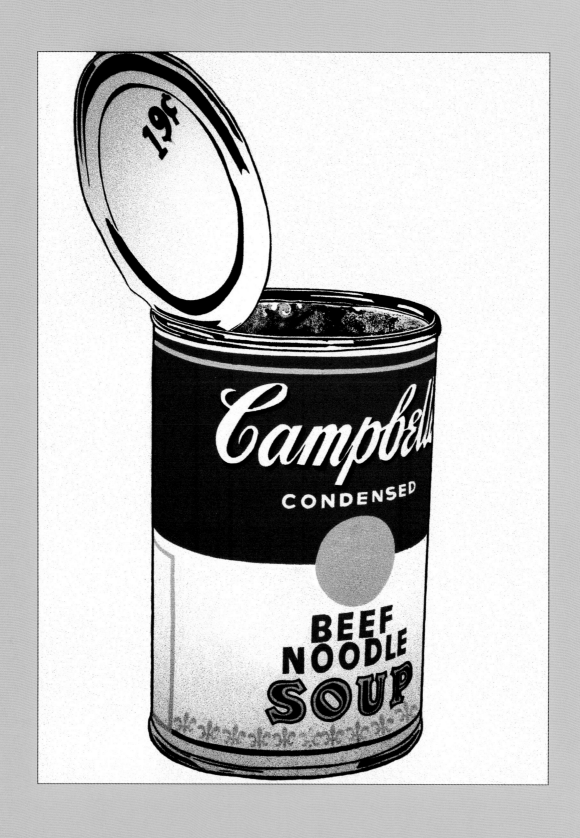

BIG CAMPBELL'S SOUP CAN, 19¢, 1962

The Menil Collection, Houston
Mixed media on canvas - 182.9 x 138.4 cm

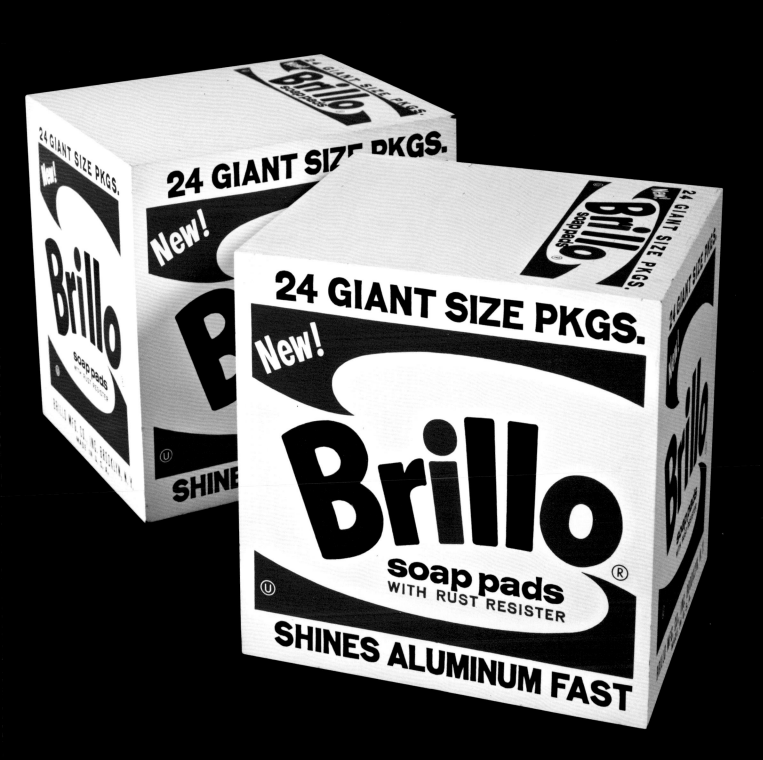

BRILLO BOXES, 1970 (REFABRICATION OF 1964 PROJECT)

Allen Memorial Art Museum, Oberlin College
Silkscreen inks on industrially fabricated plywood box supports - 50.8 x 50.8 x 43.2 cm

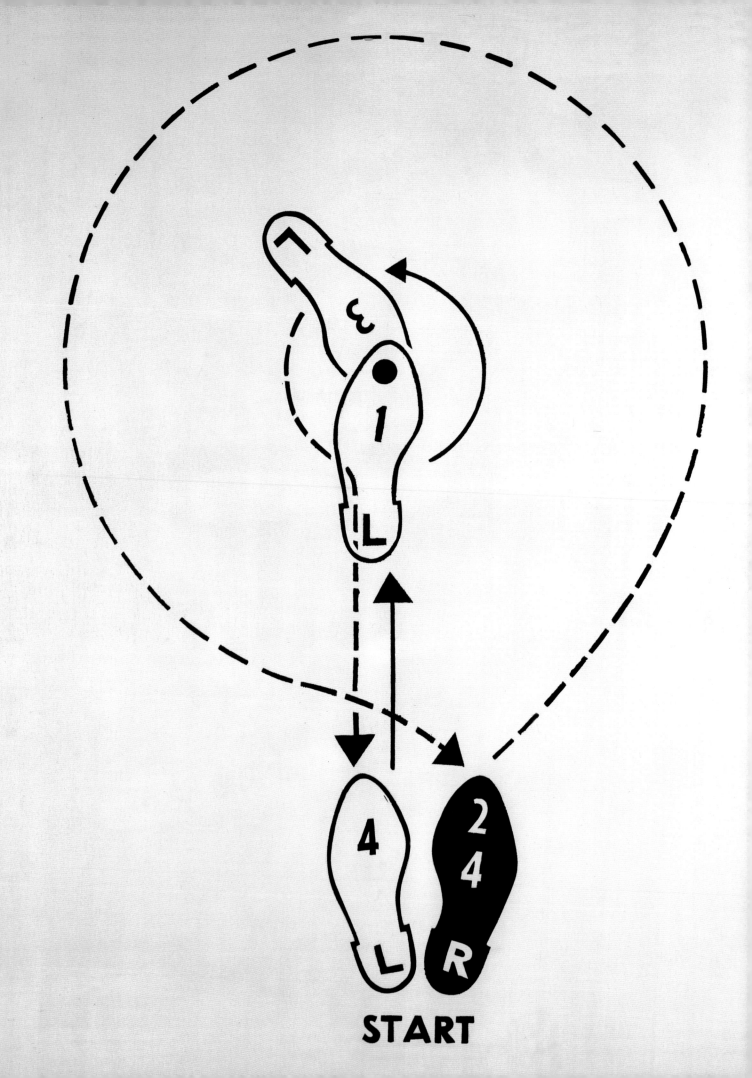

START

DANCE DIAGRAM - FOX TROT, 1962

Hamburger Kunsthalle, Hamburg - Acrylic on canvas - 183 x 137 cm

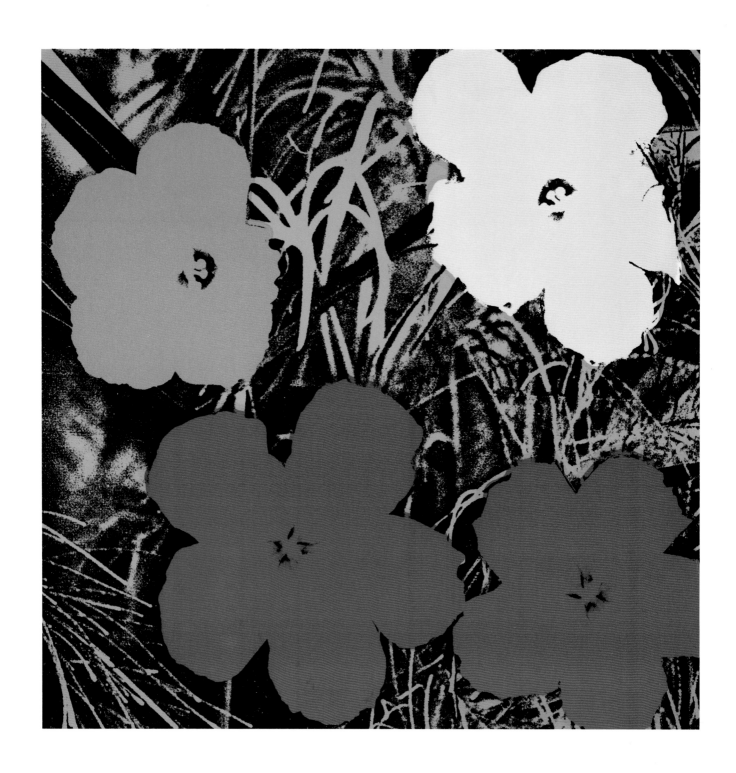

FLOWERS, 1970

The Andy Warhol Foundation for the Visual Arts, Inc., New York
Screenprint on paper - 91.4 x 91.4 cm

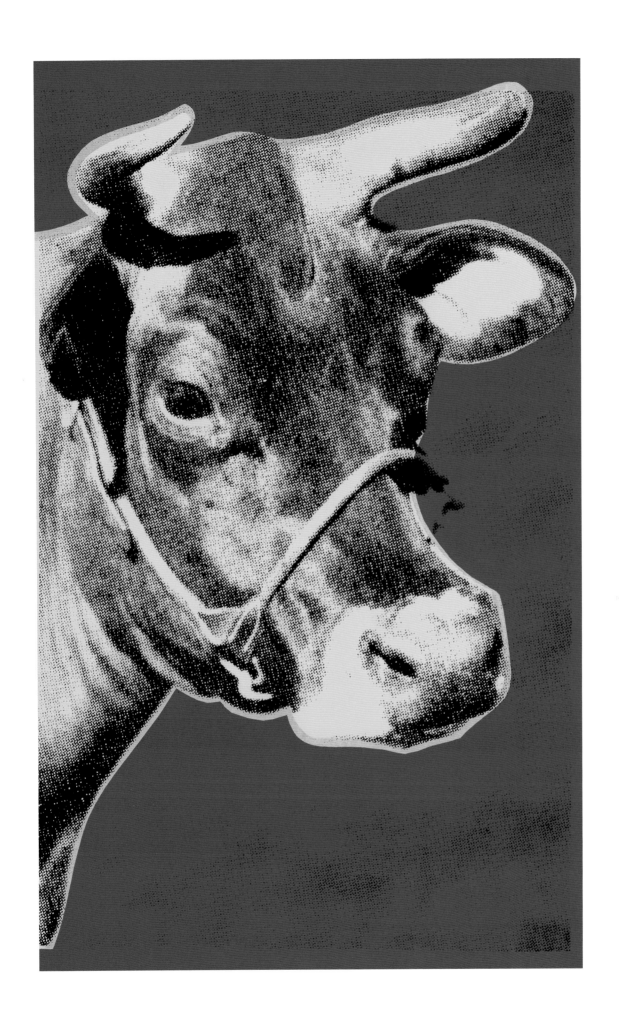

Cow, 1971

Museum of Modern Art (MoMa), New York - Screenprint - 115.6 x 75.6 cm

FIESTA PIG, 1979

The Andy Warhol Foundation for the Visual Arts, Inc., New York
Screenprint on Arches 88 paper - 54.6 x 77.5 cm

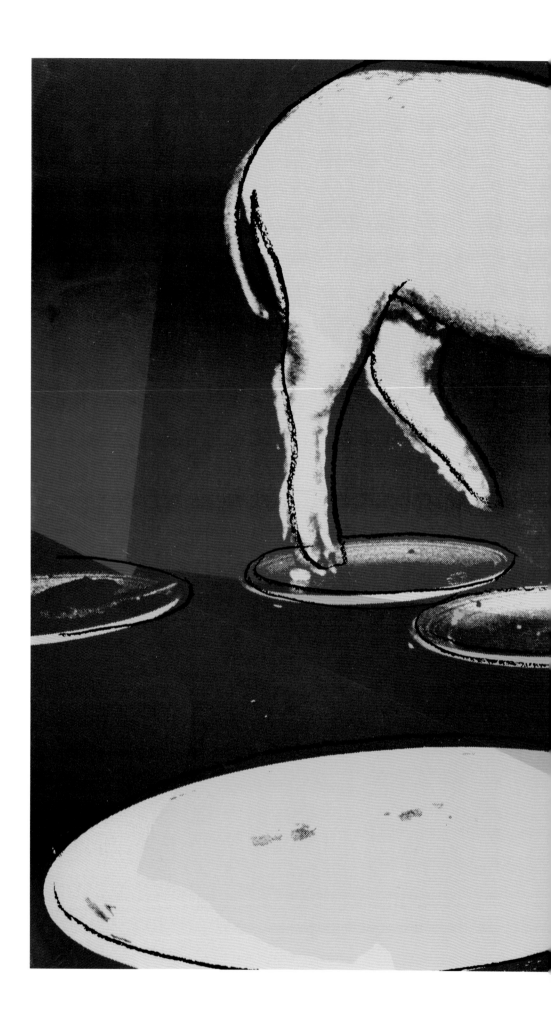

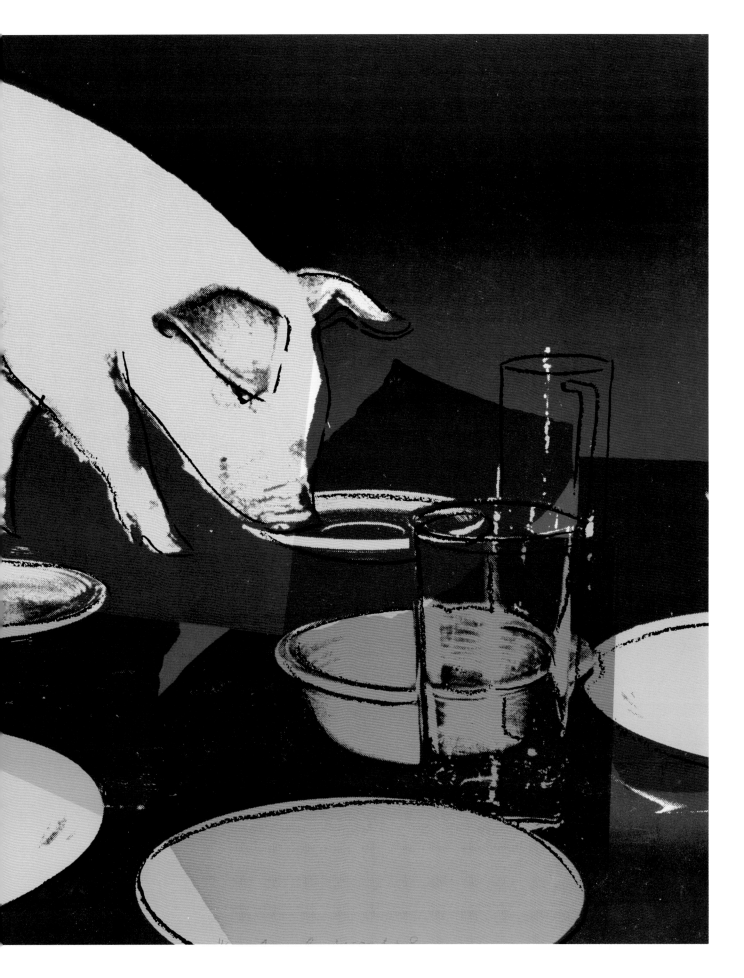

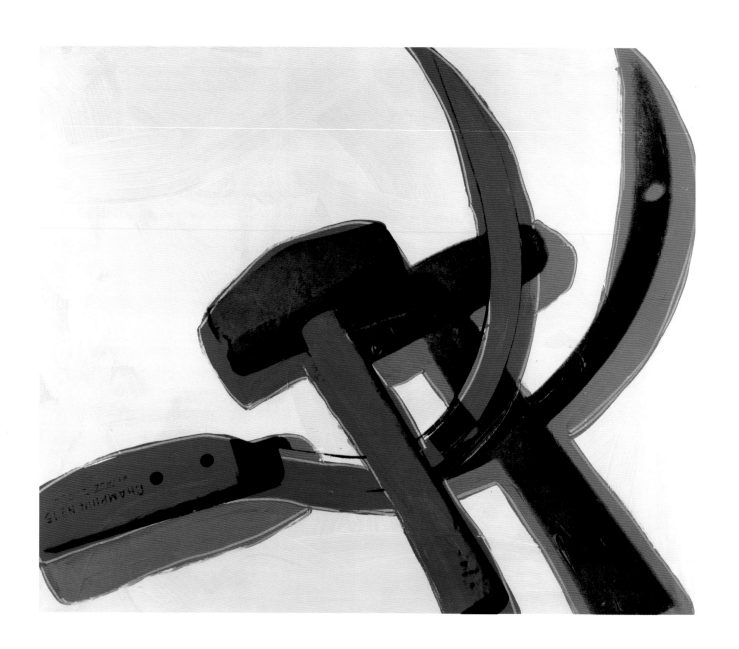

HAMMER AND SICKLE, 1970

Hamburger Kunsthalle, Hamburg
Silkscreen ink on synthetic polymer paint on canvas - 25.4 x 33 cm

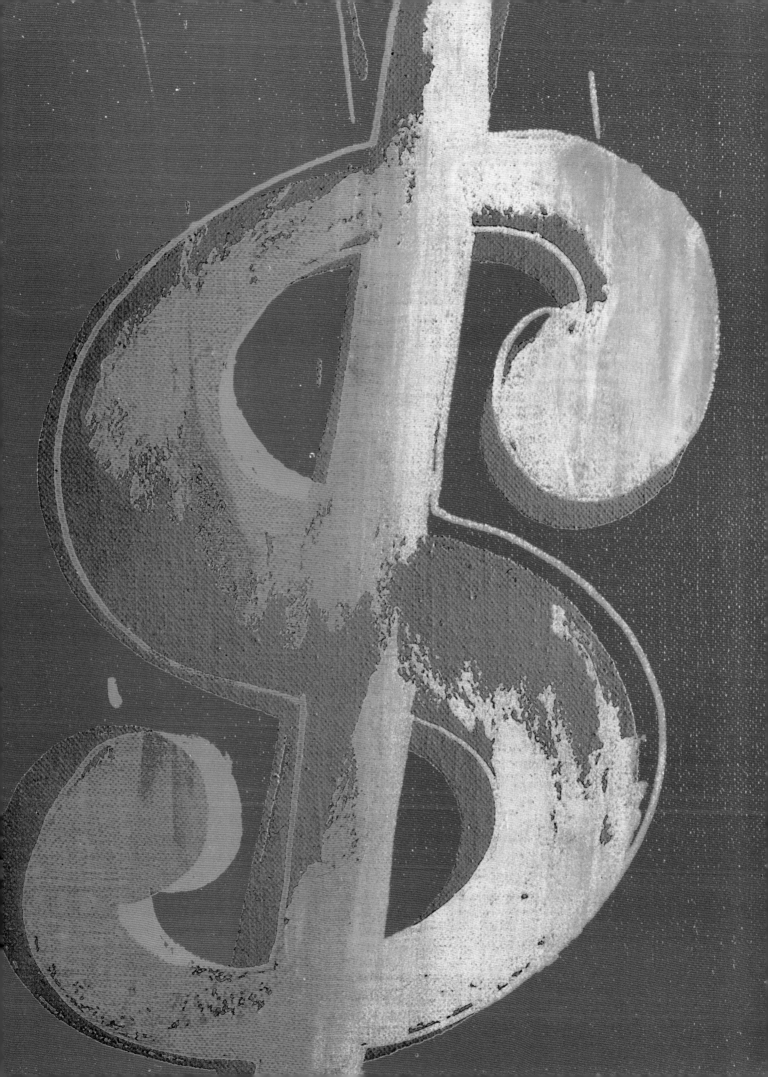

EARLY ELECTRIC CHAIR, 1963
Private Collection - Synthetic polymer paint and silkscreen ink on canvas - 51 x 76 cm

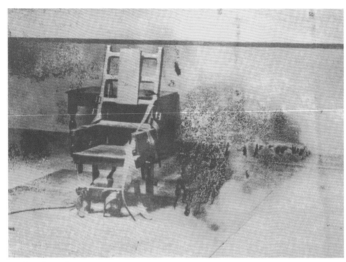

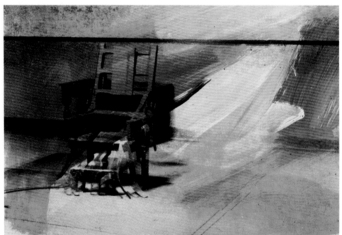

ELECTRIC CHAIR, 1971
Hamburger Kunsthalle, Hamburg
Screenprint on paper - 88.9 x 121.9 cm

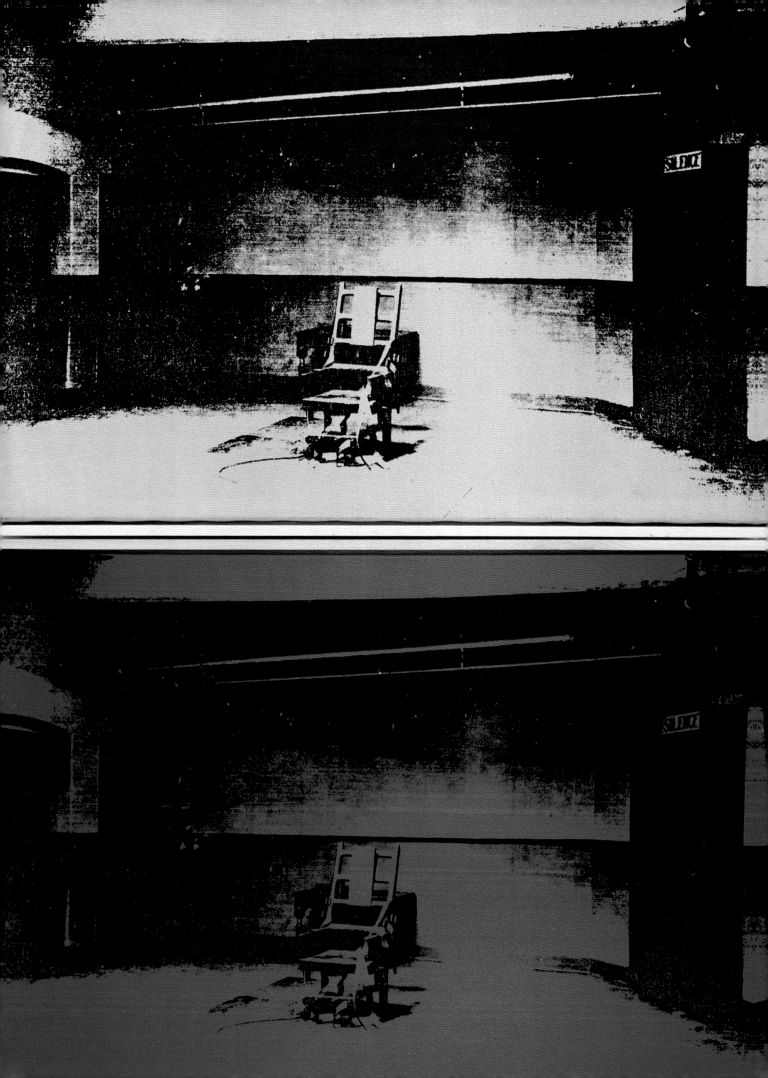

"Take an object.
Do something to it.
Do something else to it..."

Jasper Johns

One of the key figures in the American Pop Movement in the 50s is undoubtedly Jasper Johns. Johns was first and foremost a painter and would remain so all his life. His painting deliberately detaches itself from the impulsive gesticulation of Action Painting, thus becoming schematic, regular and almost impersonal. If Duchamp had discovered a new way to measure himself against tradition, with the invention of "ready mades," Johns goes further, turning the Duchampian object into a picture. This was the beginning of the flags, the beer cans, the target or the painted numbers, with an objective which moves away from the aesthetics and the pathos of Abstract Expressionism permanently, attempting a return to pure and simple reality, and thus announcing the dawn of a new era, the Pop Age. As with the artists of the New Dada movement, to which Johns remained closely linked, the common everyday object was revised, without surrendering to the temptation of ennoblement. His approach is neither sentimental nor evocative. In one of his most important paintings, the series dedicated to the American flag (*Flags*), this tendency to confer a simple connotation of use, is made clear.

The American flag is depicted in different ways by Johns: sometimes with a flat surface, on another occasion by super-imposing three flags of different dimensions.

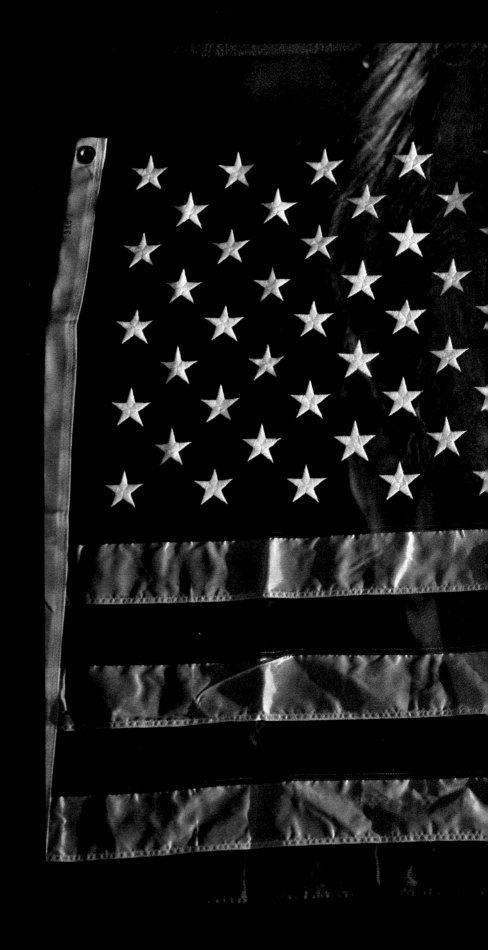

The use of this icon signals the beginning of a new trend which the more specifically Pop artists were soon to explore: the American flag, the sacred image of the nation, icon of patriotic feeling, whose values, thanks to John's new interpretation, were processed, removed from their steadfastness, and once again laid open for fresh interpretation and discussion. The flag, considered as a symbol, becomes a pretext for questioning a whole culture.

In the *Painted Bronze* beer cans, two perfectly identical Ballantine cans with a bronze finish, are seen for just what they are: a consumer product, notwithstanding the fact that the reproduction technique is still linked to that of Expressionism.

It can be said that the fundamental difference between Johns' work and that of other Pop artists lies specifically in his choice of subjects. Warhol's cans, just like Oldenburg's sculptures are products which have just left the factory, anonymous, part of a series, ready for the shelves. Johns' subjects, on the other hand, are cloaked in mystery, conferred on them by the regular brush strokes and the use of an elevated technique such as wax encaustic. His days are devoted to the more recent pictorial tradition, still linked to the representation and the veneration of a work of art as a reflection of what is sacred.

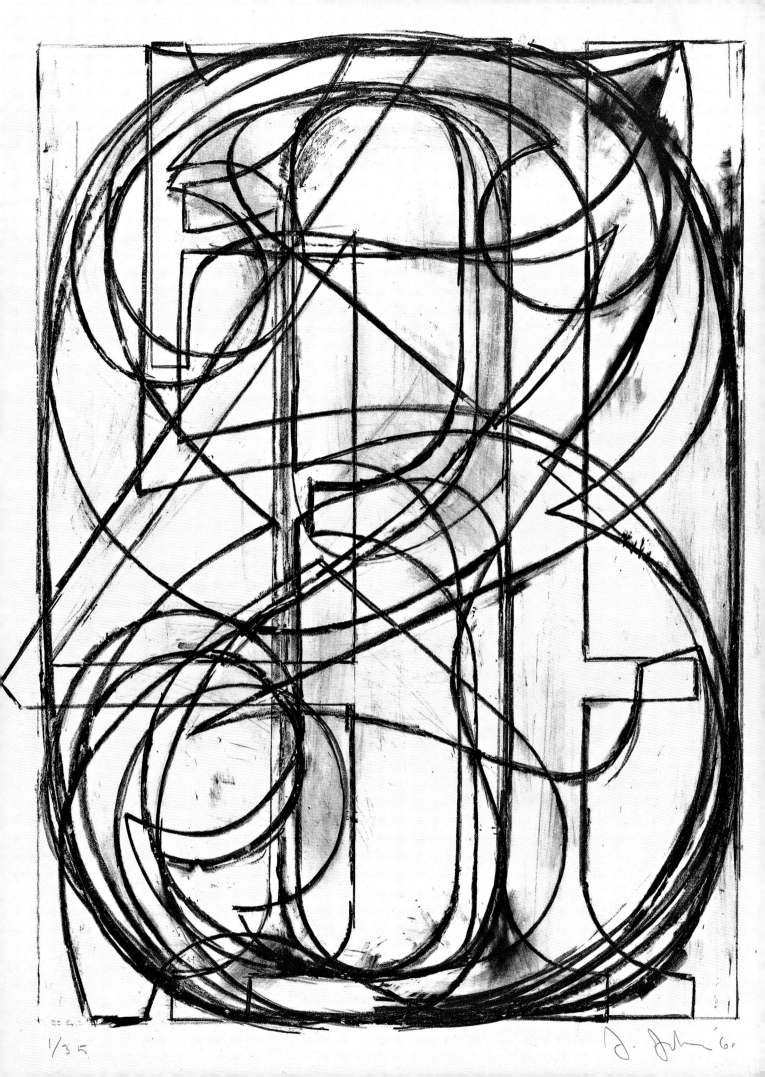

1/35 J. Johns '60

TARGET WITH PLASTER CASTS, 1955

Private Collection
Encaustic and collage on canvas with objects - 129.5 x 111.8 x 8.8 cm

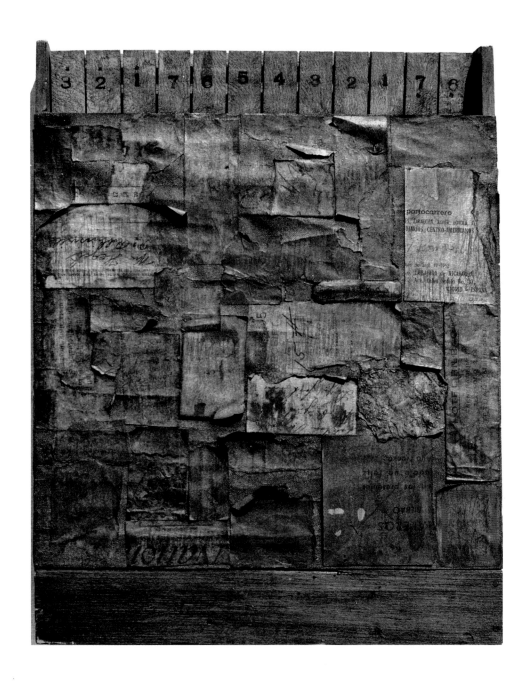

CONSTRUCTION WITH TOY PIANO, 1954

Kunstmuseum, Basel
Graphite and collage with toy piano 29.4 x 23.2 x 5.6 cm

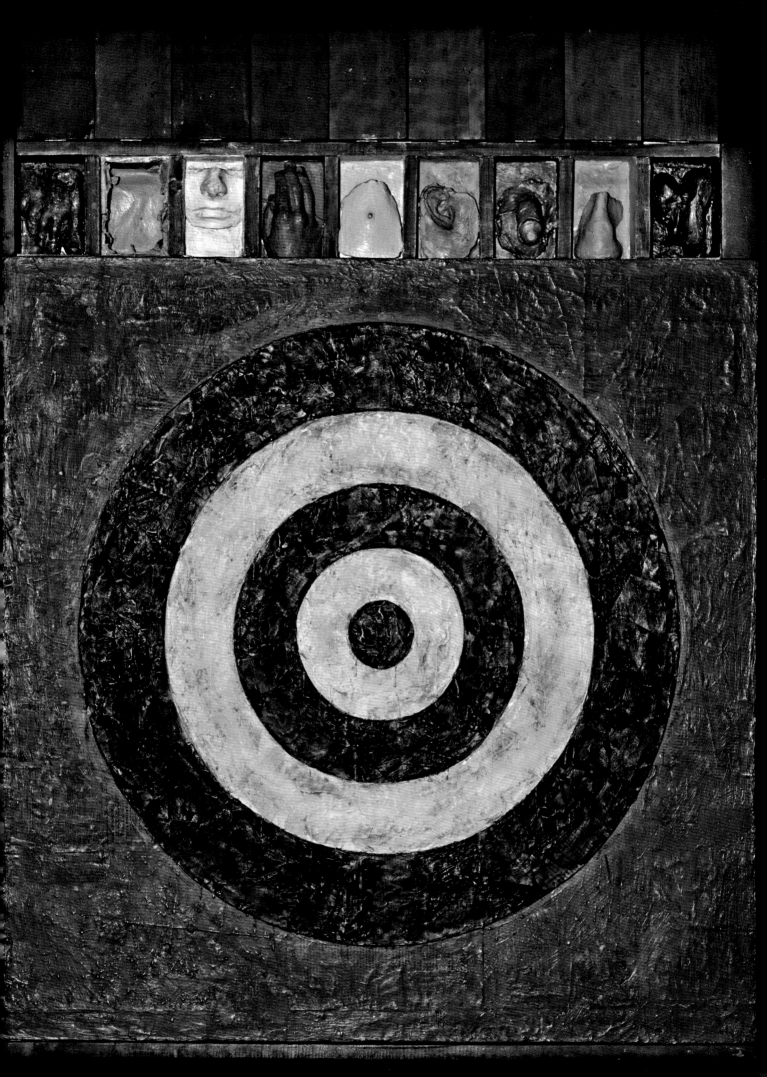

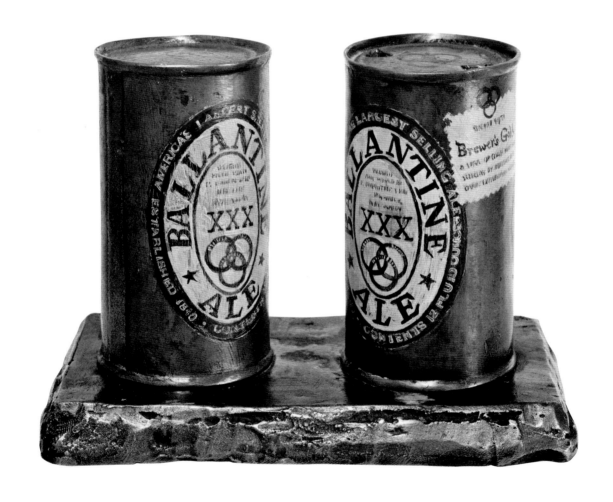

PAINTED BRONZE II: ALE CANS, 1964

Private Collection - Painted bronze - 13.7 x 20 x 11 cm

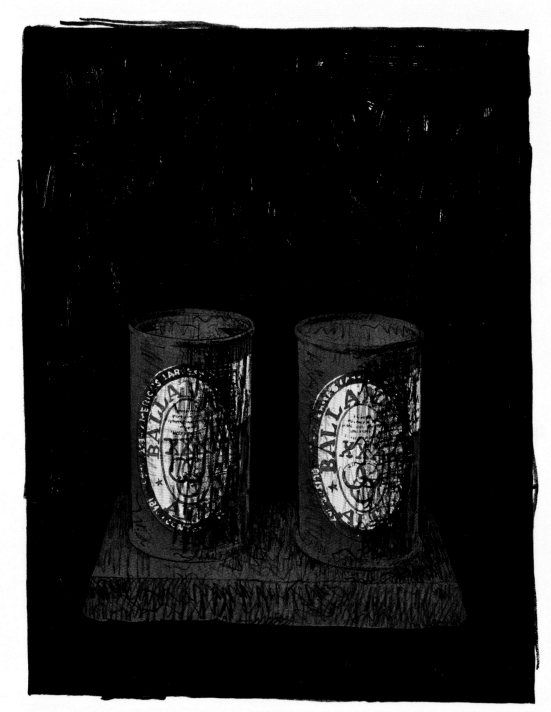

1/31

J. Johns '64

"Any incentive to paint
is as good as any other.
There is no poor subject...
Painting relates to both art
and life... I try to act in that
gap between the two."

Robert Rauschenberg

Rauschenberg was a friend of Jasper Johns (with whom he shared an apartment in New York for some time) and was also influenced by the poetics of John Cage. With Cage he attended Black Mountain College and took part, in 1952, in the first "happening" in history. In his early work, the monochromes of the *White Paintings* and *Black Paintings* series, there is a certain tendency to translate into painting what Cage was theorizing in music. Thus, the canvases seem to emerge from the reflection of what was happening around the frame, enclosed in that undetermined space between life and art, between chance, entropy, and the artist's intentions. Dripping paint traces a human silhouette, giving the impression of tri-dimensionality, as well as the idea of waking from a dream.

The picture *Bed* is on two levels: a higher more chaotic part, which rests on the lower more geometric part. It is here that his artistic intuition comes to light: a ready-made element enriched by an assembly of Dada origin. Thus, using different objects and materials from those of Duchamp, Rauschenberg, with his friend Jasper Johns, became a historical link between Post Dadaism and real Pop Art. Indeed, Rauschenberg's objects, having been removed from reality, are emphatically overstated by the way they are

65 Robert Rauschenberg was born in Port Arthur on 22 October 1925 and died in Captiva Island on 12 May 2008.

67 **Magician II, 1959**
Ileana and Michael Sonnabend Collection, New York
Combine painting - 166 x 97 x 41 cm.

painted which allows him to set them in harmonious and highly aesthetic compositions.

They are things which are borrowed from everyday life, and which lose nothing of their authenticity. This is the case for example, of the chair which, even though blended into the canvas, maintains its vertical position, thanks to the legs resting on the floor, and therefore is not removed from its usual semantics.

Time 3 (1961) finally completes the path initiated with the *Combine Paintings*: a massive wall clock, of the type which were used in kitchens in the 60s, is stuck onto the white surface of a picture.

The white of the background and that of the clock create a perceptive illusion, which cancels the object's outline, the embossing along the edge, and creates an indiscriminate exchange between the inside and the outside, between order and disorder.

Rauschenberg's clocks, bottles of Coca-Cola, stuffed animals, fans and radios are objects which, when detached from their usual role and placed in the context of an abstract picture, acquire a different meaning, thus leading the observer to reconsider the landscape of daily life.

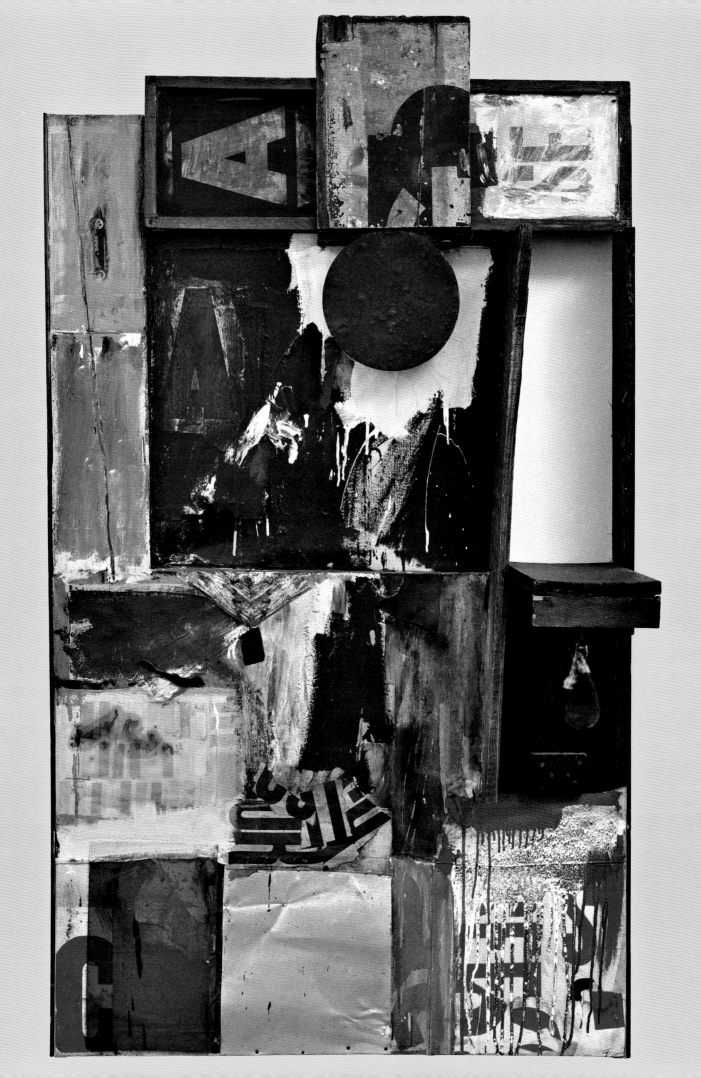

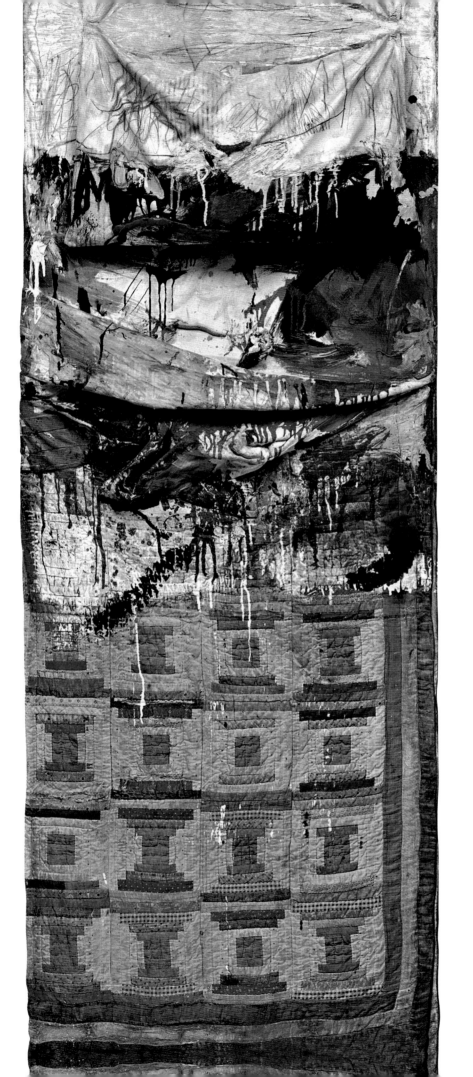

BED, 1955

Museum of Modern Art (MoMa), New York - Combine painting - 191.1 x 80 x 20.3 cm

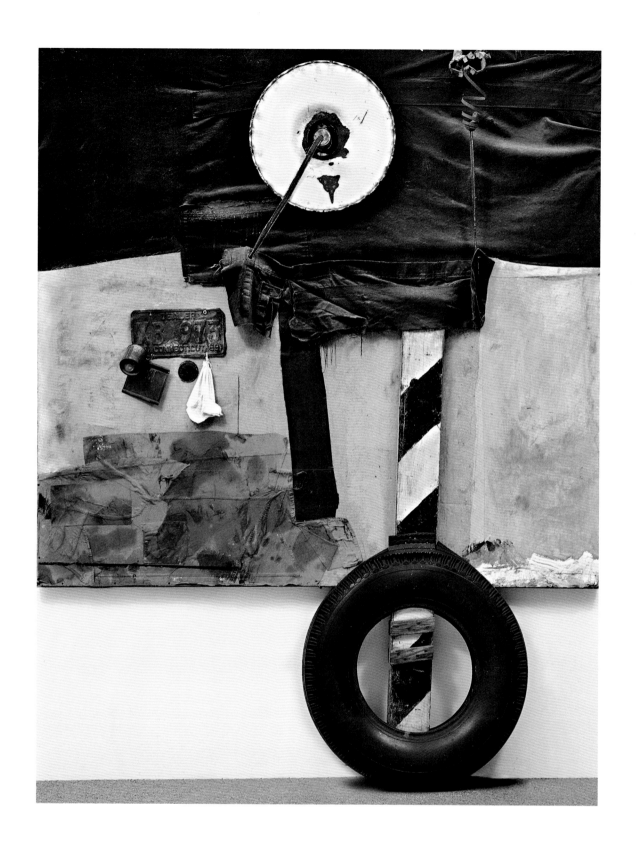

First Landing Jump, 1961

Museum of Modern Art (MoMa), New York
Combine painting - 226.3 x 182.8 x 22.5 cm

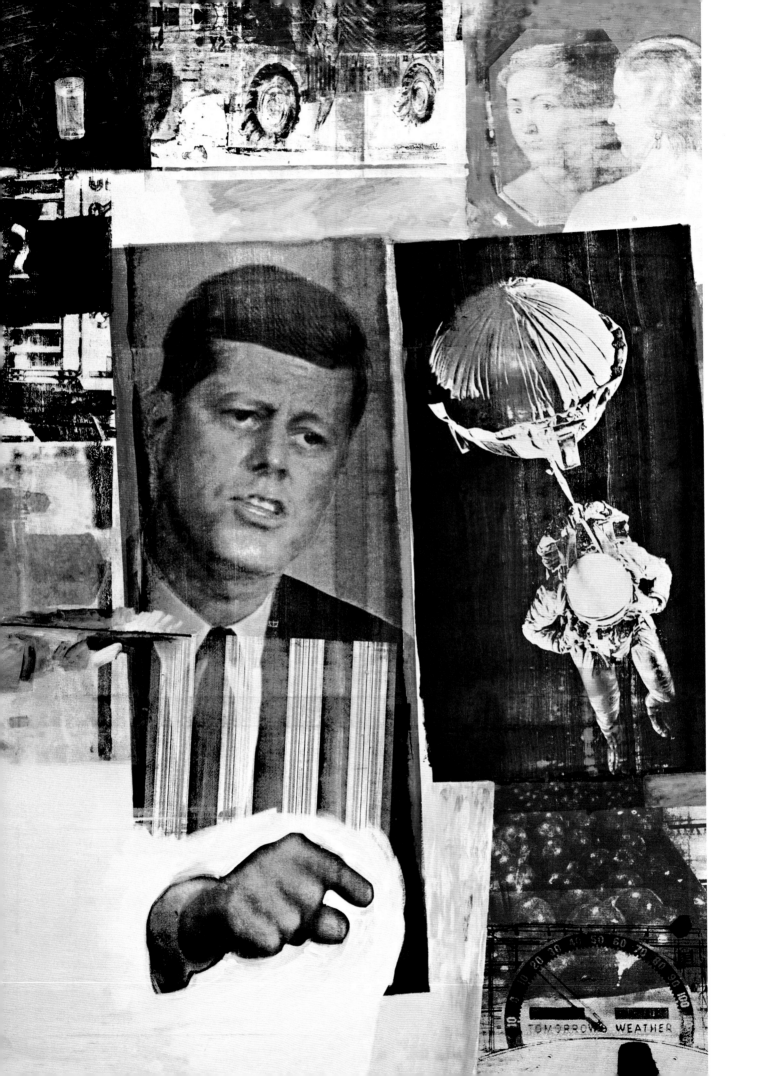

TOMORROW'S WEATHER

Retroactive II, 1964

Stefan T. Edlis Collection, Chicago - Oil and silkscreen on canvas - 213 x 152 cm

Canto XXXI, 1959-60

Museum of Modern Art (MoMa), New York
Drawing, colored pencil, gouache, and pencil on paper - 36.8 x 29.3 cm

"Art doesn't transform.
It just plain forms."

Roy Lichtenstein

Together with Andy Warhol, he is considered to be the artist who has most faithfully interpreted Pop style. Having trained alongside Abstract Expressionists, Roy Lichtenstein's subjects are modified by the iconography of the cartoon world, then enlarged and painted on a uniform printing mesh. The bold outlines and the grid structure of the surfaces, highlight an image that is processed like a television image. Lichtenstein's subjects are a focus, or a zoom effect on a detail, such as an eye, taken from the succession of storyboard frames or comic strips, and, of course, full of life.

In *Image Duplicator* (1963), Lichtenstein succeeds in encapsulating all his style. At the very front two frowning eyes, painted with the enlarged pointillism technique, represent the iconographic simplification of the comic strip, which is applied to all his work, suggesting the idea of an image composed of pixels, which can be associated both formally and conceptually with the new mass languages.

In the balloon which covers part of the forehead, the man asks himself: "What? Why did you ask that? What do you know about my image duplicator?"

Girl with Ball (1961) is an anonymous reproduction

of an advertising poster, which draws its subversive

power precisely from of its disconcerting banality.

The apparent lack of any artistic intention, and the use

of a low-brow, popular communication language, is the

source of an almost casual, fleeting beauty, which throws a

different light on the aesthetic enjoyment of those cultural

products which were making their first appearance precisely at

that time: comic strips, cinema, popular literature, rock.

The streaked locks, the contrast of colors, the lightness of move-

ment, give this picture the modern pleasure of viewing an artificial

world. It is as if Lichtenstein were showing us the poetry and the hid-

den beauty of mass culture, even in its more prosaic nuances.

Lichtenstein deals in pure imagery. In *Hot Dog* (1964), and even previously

with *Meat* (1962), the material reality of painted food is only hinted. The grain

of the meat and the ketchup on the sandwich, are displayed in a cartoon fashion.

In this very subtle transformation, Lichtenstein's treatment of images diverges to-

tally from that of Oldenburg where the food depicted still carries naturalistic intent.

But not all of Lichtenstein's imagery is kitsch, or in bad taste.

Indeed, as early as 1964 we find the work dedicated to models which the historical avant-garde masters had already tackled, as in the case of the remake of Picasso's *Woman with Flowered Hat*. As from the mid 60s, Lichtenstein's cartoons seem to expand before the spectator's eyes, blown up by a more decisive and detached style.

The landscapes, the dawns and the sunsets, taken from tourist posters and constructed geometrically on an accentuated horizon using three main colors, become more and more abstract.

Lichtenstein's pictures, like his sculptures, treated in a two-dimensional fashion as if they were pictures, feature a whole world of banal and inferior artifacts, that are re-proposed to an astonished gaze that attempts to redeem them.

75 Roy Lichtenstein was born in New York on 27 October 1923 and died there on 29 September 1997.

78-79 A curious picture of Roy Lichtenstein taken in his studio in Manhattan in 1992.

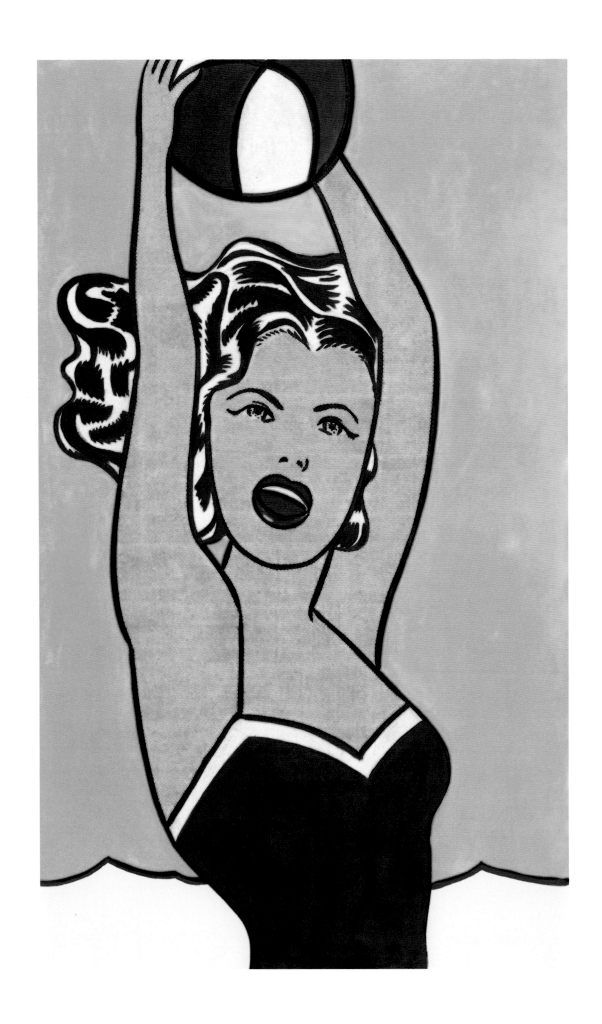

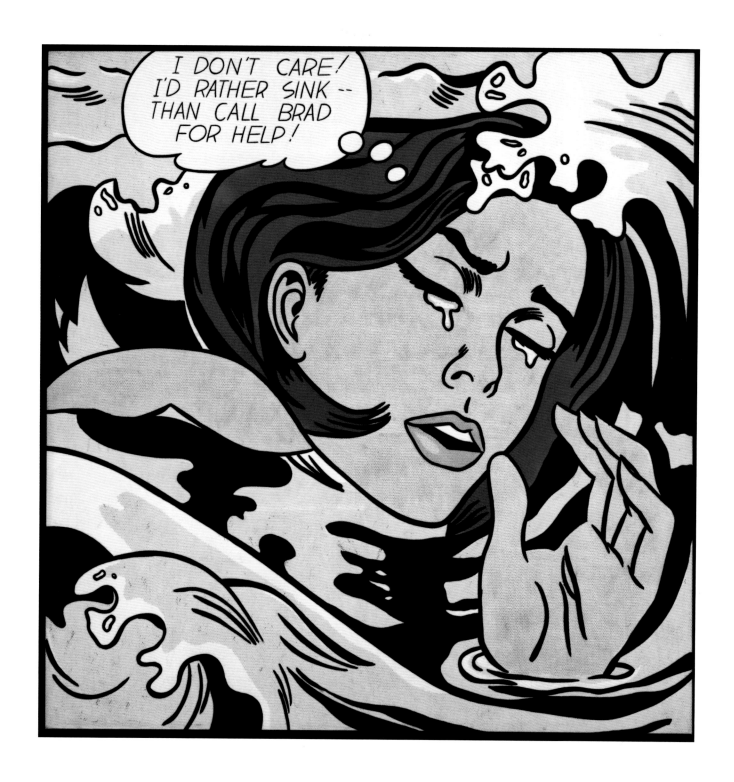

DROWNING GIRL, 1963

Museum of Modern Art (MoMa), New York
Oil and synthetic polymer paint on canvas - 171.6 x 169.5 cm

HOT DOG, 1964

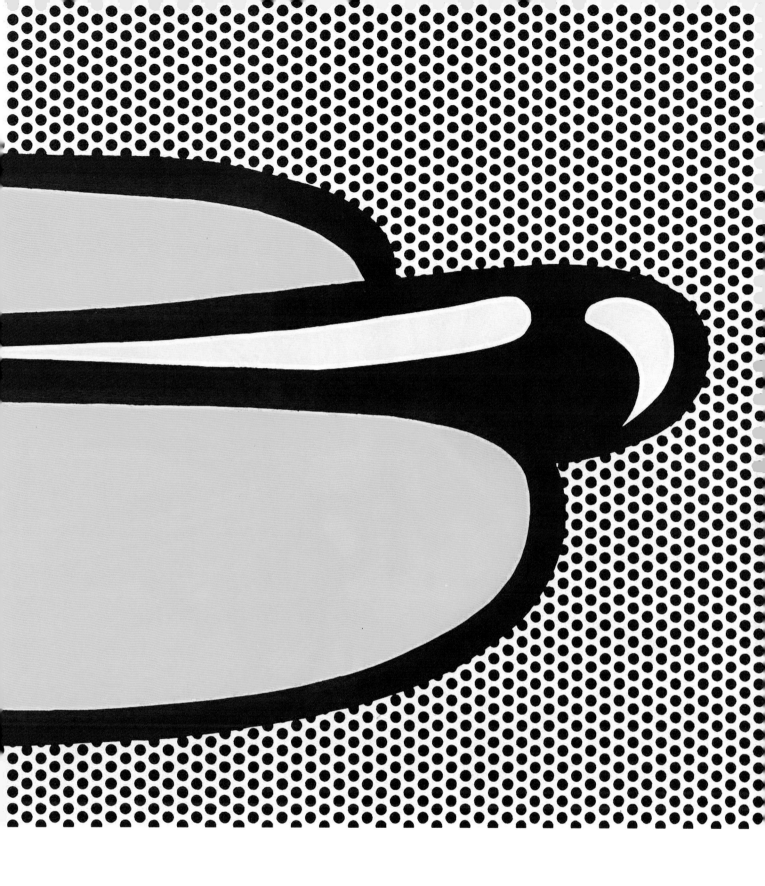

Musée National d'Art Moderne - Centre Pompidou, Paris
Enamel on plate - 61.2 x 122.2 cm

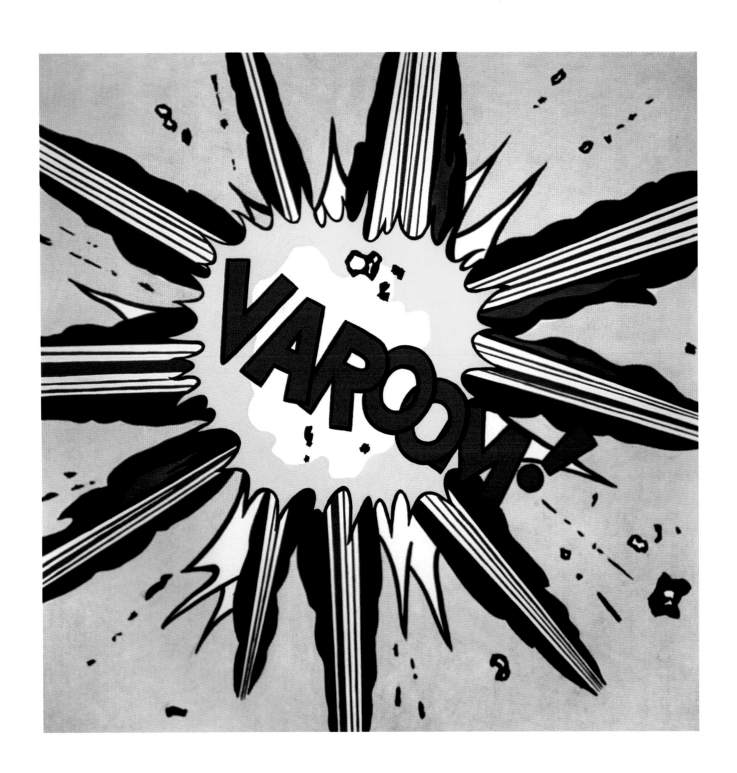

VAROOM! 1963

Private Collection - Magna on canvas - 142.2 x 142.2 cm

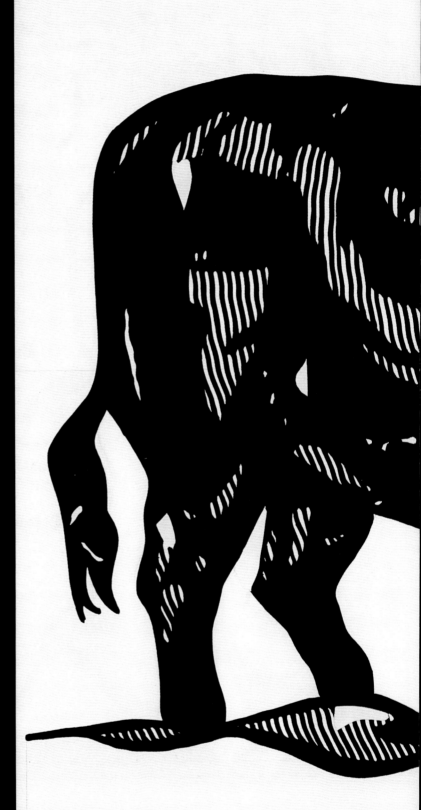

STUDY FOR BULL I, 1973

Museum of Modern Art (MoMa), New York
Cut-and-pasted paper, ink and pencil on paper
72.3 x 98 cm

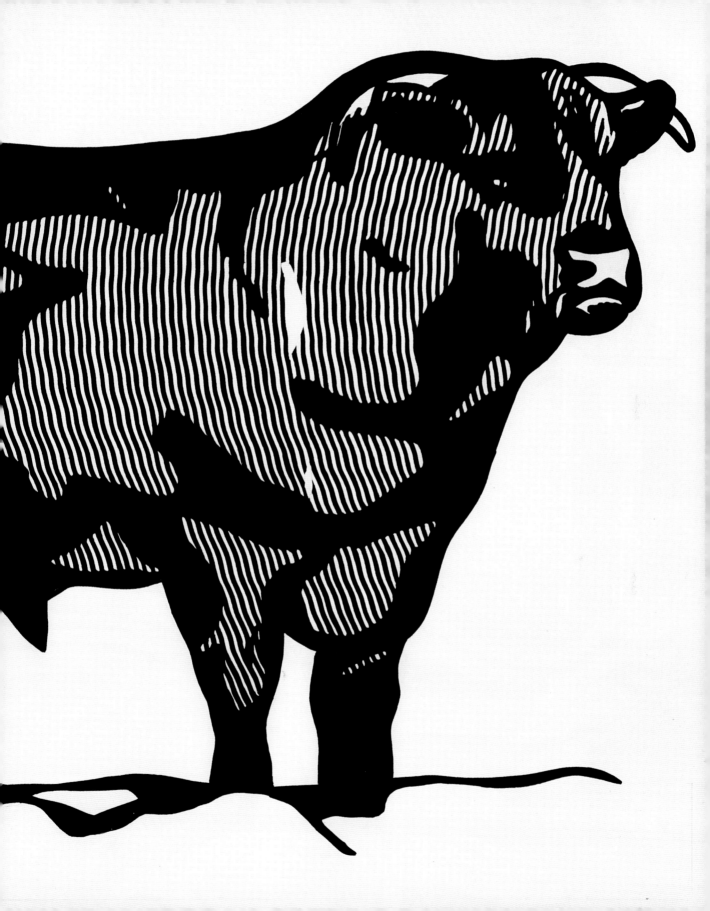

"I like to think that
my work is about
all kinds of pleasure."

Tom Wesselmann

After being a psychology student at the University of Cincinnati between 1951 and 1952, Wesselman became involved in art around 1955. His work reflects the influence of all the Pop artists of the time, but unlike Oldenburg's subjects and Rauschenberg's assemblages, his work concentrates more on life situations, pieces of reality stolen and replaced using a language which recalls styles and forms of the past. Thus, in his paintings it is easy to recognize the brilliance of colors typical of Matisse, the geometric compositions of Mondrian as well as the sinuous forms of Modigliani.

The Great American Nude (1961), where the female figures express overt eroticism fall into this trend. Bodies which open the imagination, which, in the beginning, Wesselmann painted in full, without any inhibition, until his gaze began to concentrate on detail. From the legs spread apart in the foreground, bursts the blue of the sea, or the shape of a leg flung onto the line of the horizon. Wesselmann's women are not pornographic because they are too impersonal and polished. Indeed, they are young American girls, who spend hours in beauty farms getting ready for the beach or air hostesses of an airline serving the middle class.

93 Tom Wesselmann
was born in Cincinnati
on 23 February 1931
and died in New York
on 17 December 2004.

94-95 **Great
American Nude
2, 1961**
Museum of Modern Art
(MoMa), New York
Synthetic polymer
paint, gesso, charcoal,
enamel, oil, and collage
on plywood - 151.5 x
120.5 cm.

Little by little, the big nudes developed into the skill-

ful assemblages of the *Still Life* series.

The artist applied many of the symbols of the growing

consumer society onto a background of advertisement

clippings. Cornflakes, 7 Up, tinned fruit. In the mid-

60s Wesselmann felt the need to work with different

media and to use larger real objects, like a fridge door,

radiators, window frames. This series, called *Interiors*,

is permeated by a certain sentimentality, a satiric but

at the same time nostalgic approach, which at times

becomes more evident. This is the case of *Interior 2*

where a fan, a clock, perfectly attached and blended

into the painted surface are caught in a distant light, as

if they belong to a era which we already miss.

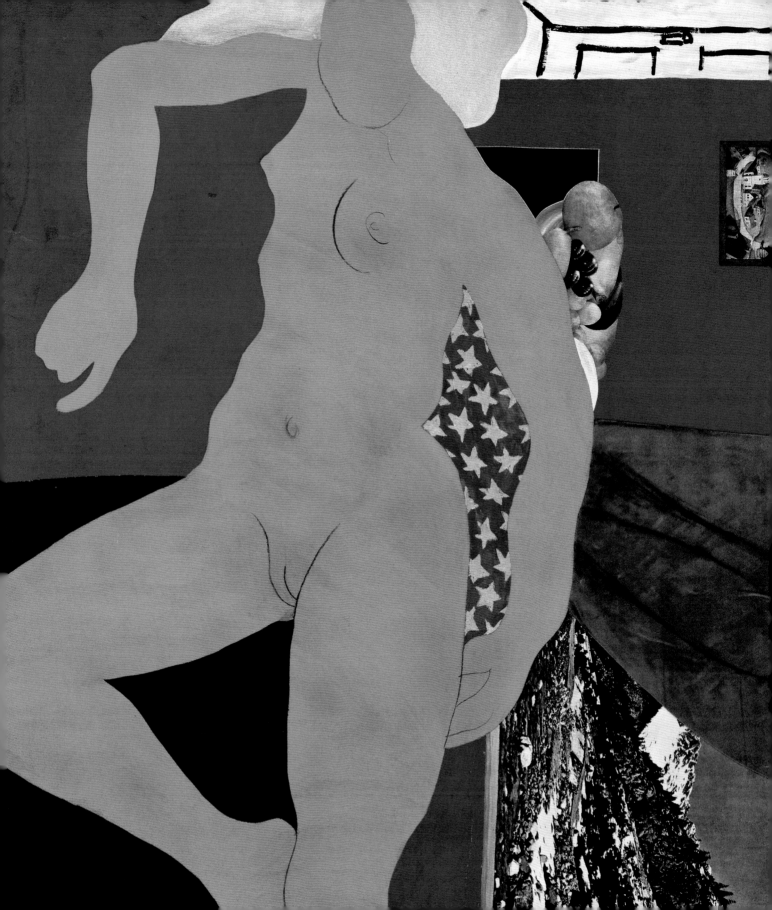

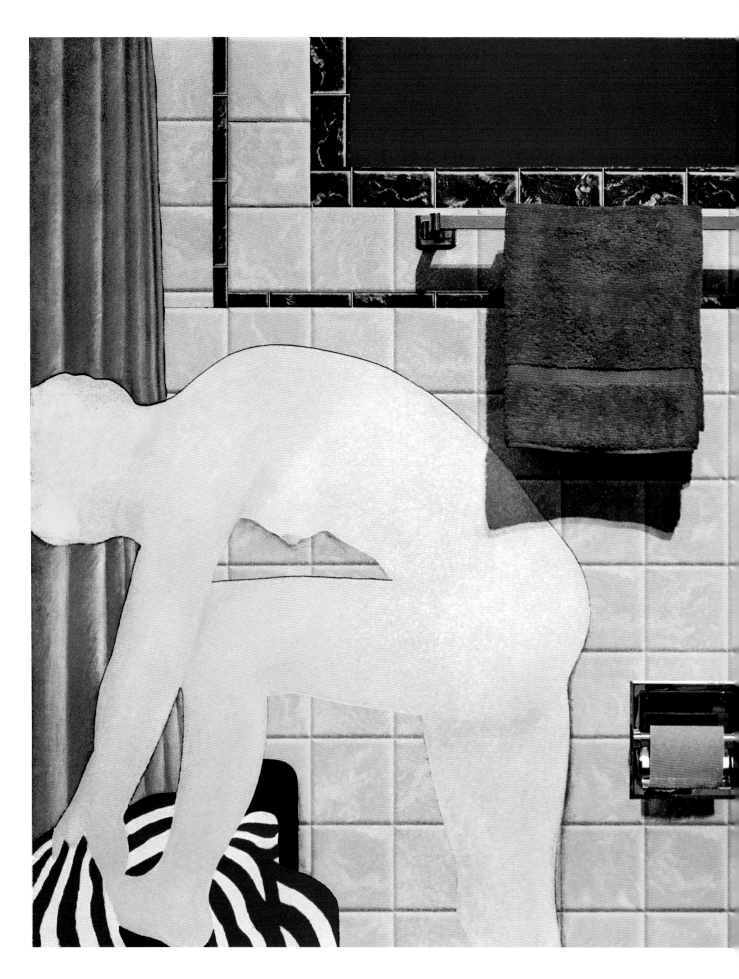

BATHTUB COLLAGE # 1, 1963

Museum für Moderne Kunst, Frankfurt

Oil color, varnish on chipboard with mounted objects and materials - 122.5 x 152.8

STILL LIFE # 30, 1963

Museum of Modern Art (MoMa), New York

Oil, enamel and synthetic polymer paint on composition board 122 x 167.5 cm

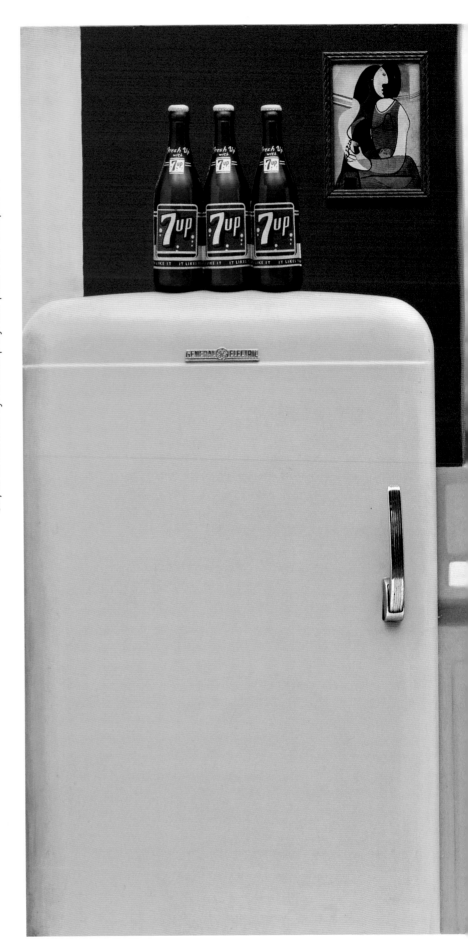

100-101
Still Life Number 36, 1964
Whitney Museum of American
Art, New York
Oil and collage on canvas
304.8 x 488.3 cm.

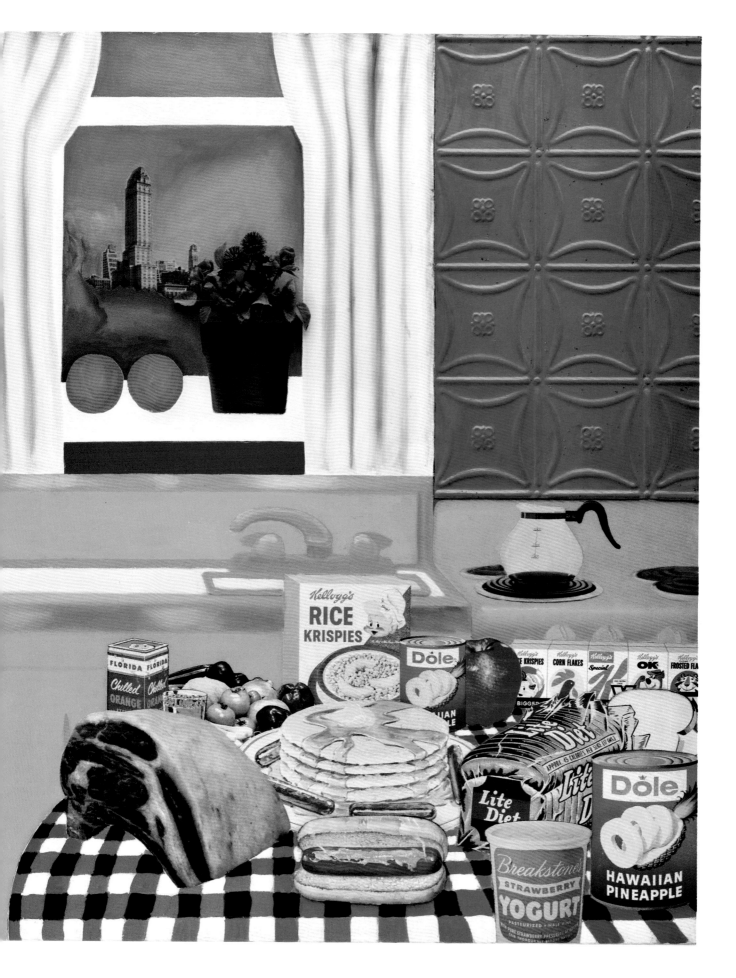

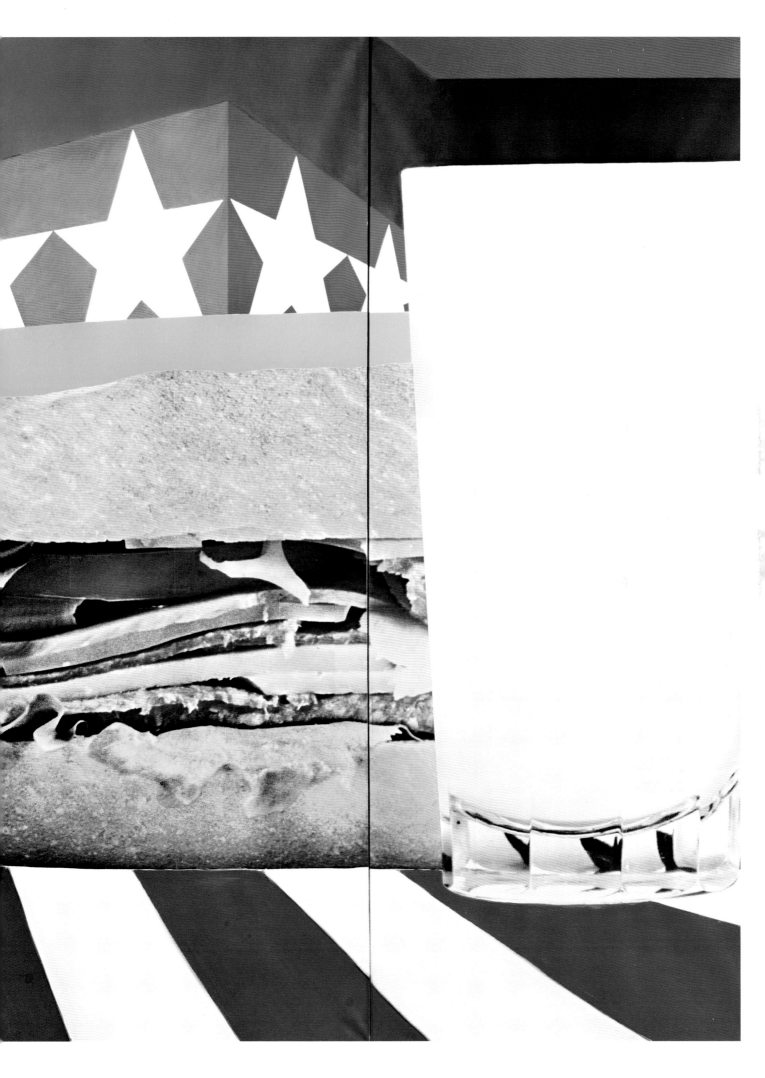

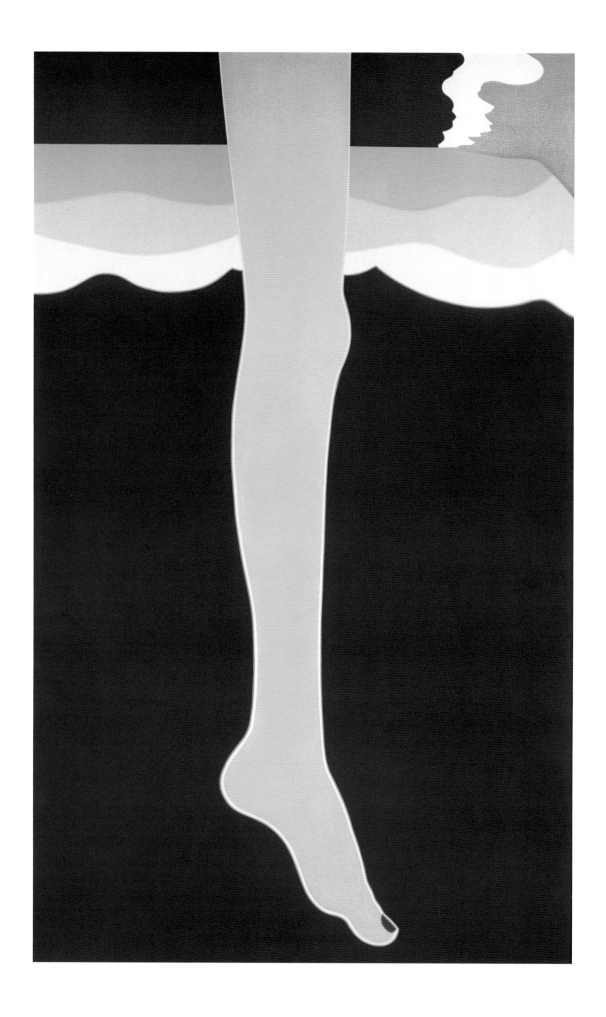

GREAT AMERICAN NUDE # 99, 1968

Morton G. Neumann Collection, Chicago
Oil on canvas - 152 x 206 cm

"What you see is
what you don't get."

James Rosenquist

E ncouraged by his mother, who was a passionate artist constantly in search of work, James Rosenquist also became involved with painting. Initially his work was characterized by the typical melancholy of Abstract Expressionism.

Living in New York toward the end of the 50s, he started to paint advertising billboards in order to earn a living. Very soon he realized that this job was giving him the opportunity to explore new avenues. He fell in love with the images and the slogans which, when seen close up, seemed to lose every immediate objective reference, acquiring, however, a deep and unexpected visual fascination.

Rosenquist's work stands out essentially due to its large dimensions: enormous canvases and huge objects, painted or stuck on, which constitute an aggression on the spectator, yet leave him the time to meditate on the effects of such distortion of proportions.

F-111, on display at the Leo Castelli Gallery in New York in 1965, is 86 ft (2621.3 cm) long and 10 ft (304.8 cm) high, and has been classified as the biggest Pop picture of all time. You have to cast your glance horizontally to appreciate its complexity: bits of aluminum, bright colors and the whole vast range of objects and artifacts described.

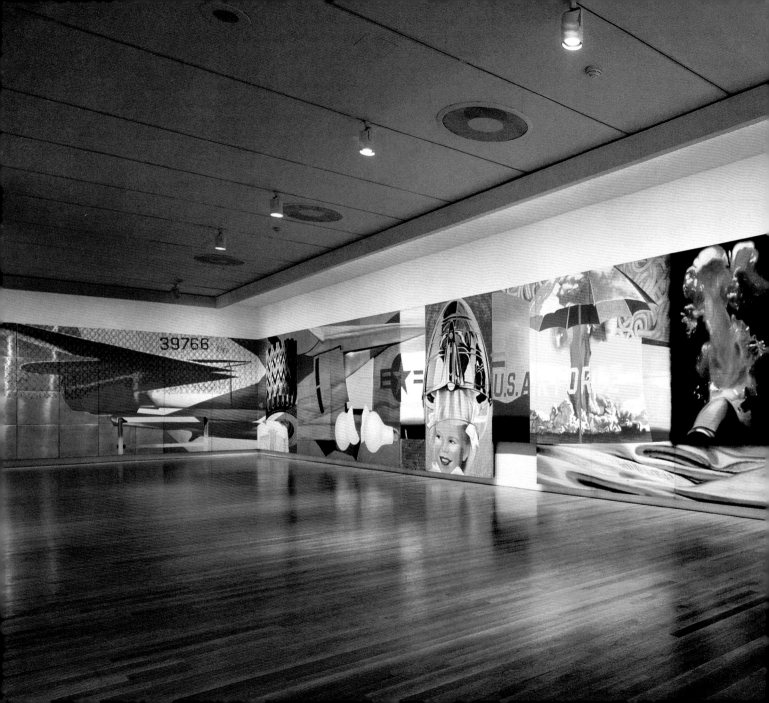

What is important for Rosenquist is to transfer attention from the natural world to the artificial world of things, thus breaking away from the Expressionist tradition. As with other Pop artists, indeed, the objects are anything but naturalistic. The materials vary from picture to picture: plastic, metal, electric and neon lights, mirrors, wood, varnish, auto-body parts. All assembled on a big scale and with an abstract sensitivity.

Rosenquist has a romantic tendency, which pushes him on, beyond his own limits.

His canvases attack us, with ferocity and energy and bring into play the seductive brutality with which radio, television and the press have invaded the social scene since the 50s.

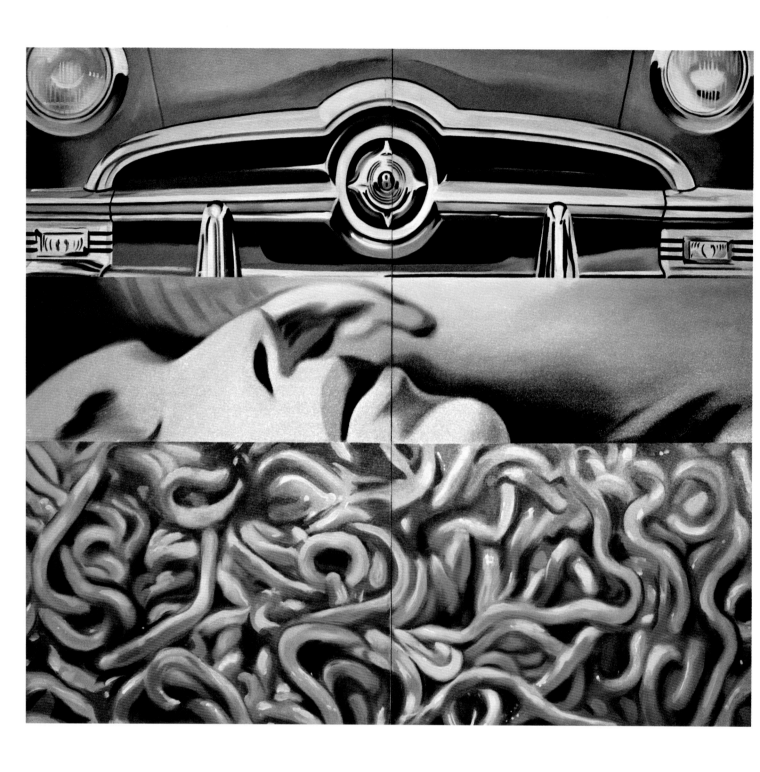

I LOVE YOU WITH MY FORD, 1961

Moderna Museet, Stockholm
Oil on canvas - 210 x 237.5 cm

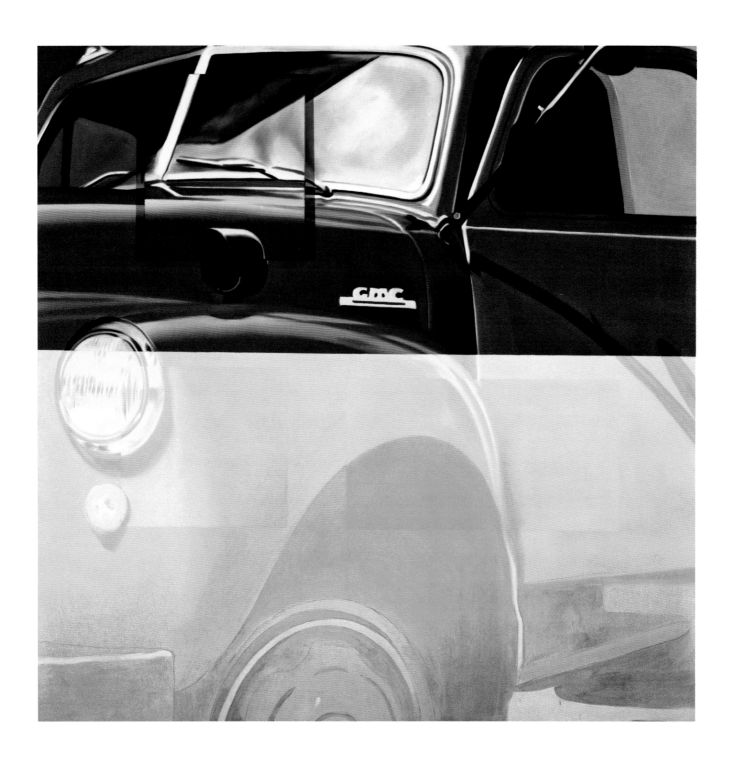

Untitled (Broome Street Truck), 1963

Whitney Museum of American Art, New York
Olio su tela - 182,8 x 182,8 cm

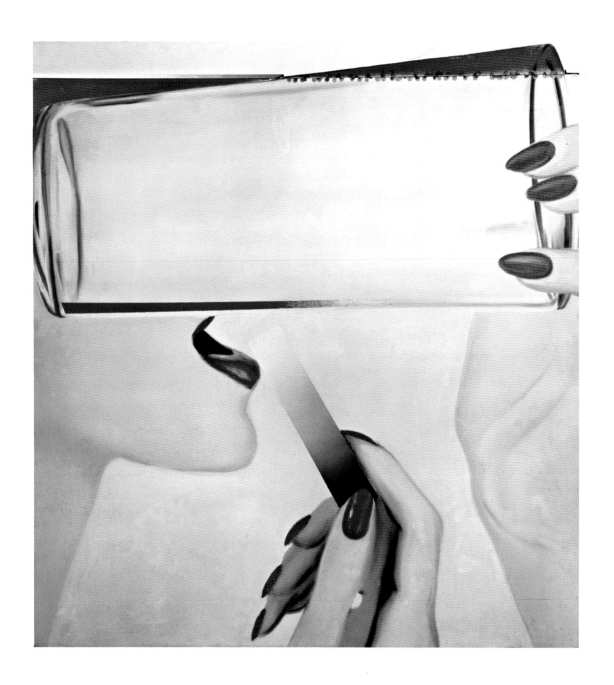

STUDY FOR MARILYN, 1962

Private Collection
Oil on canvas - 95.25 x 91.44 cm

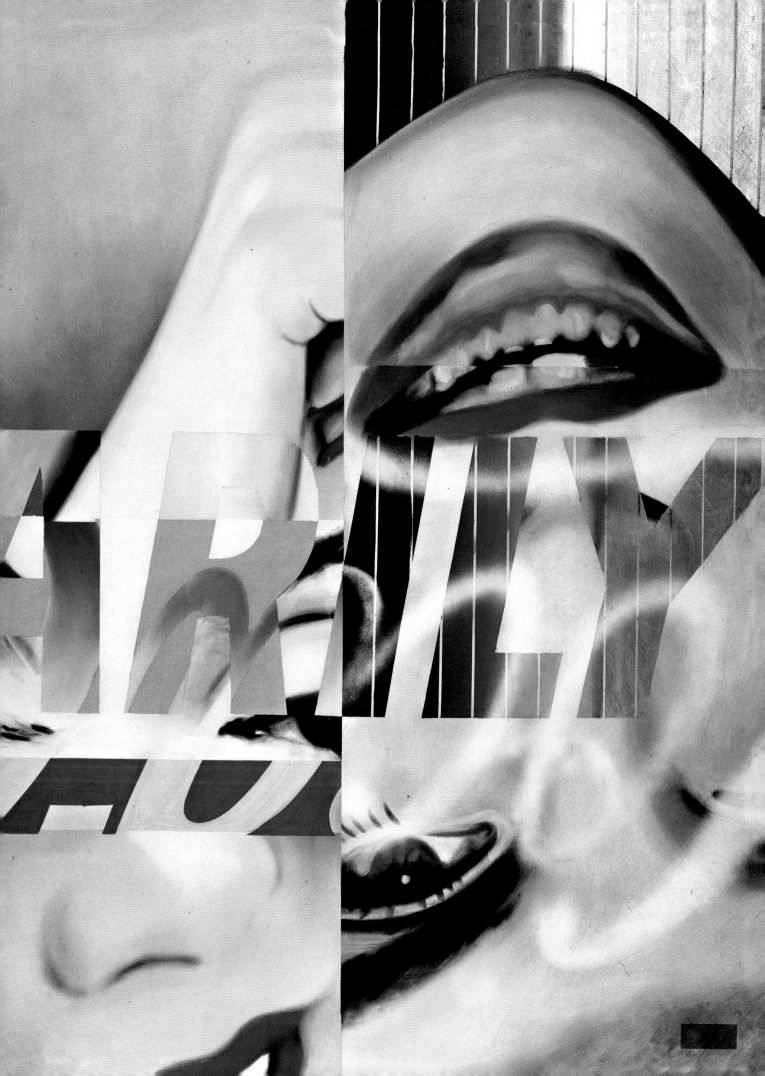

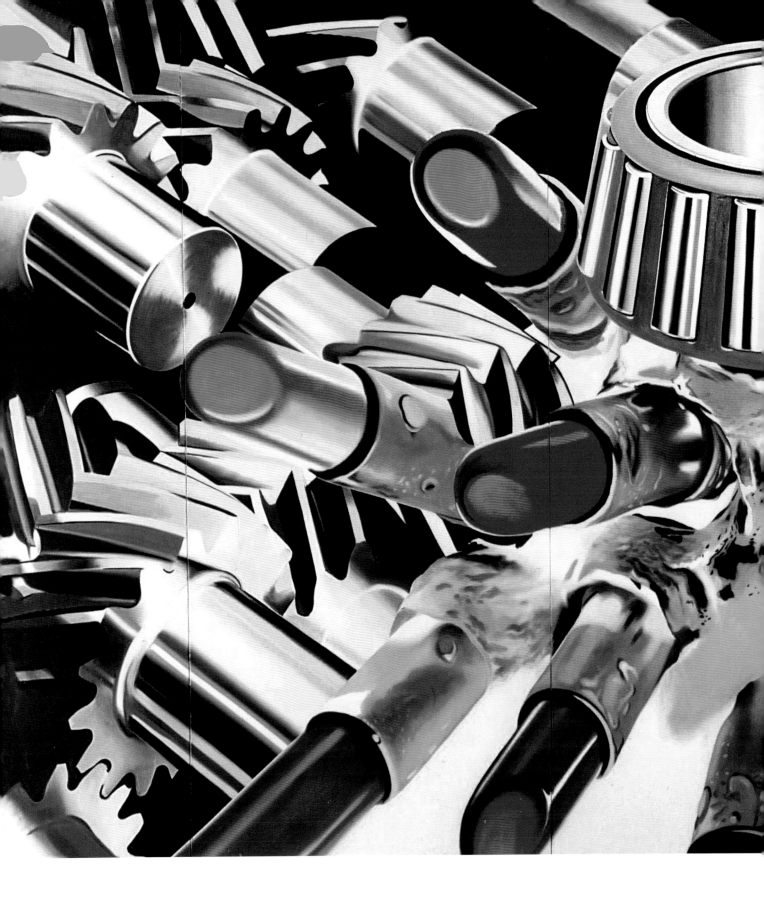

GEARS, 1977

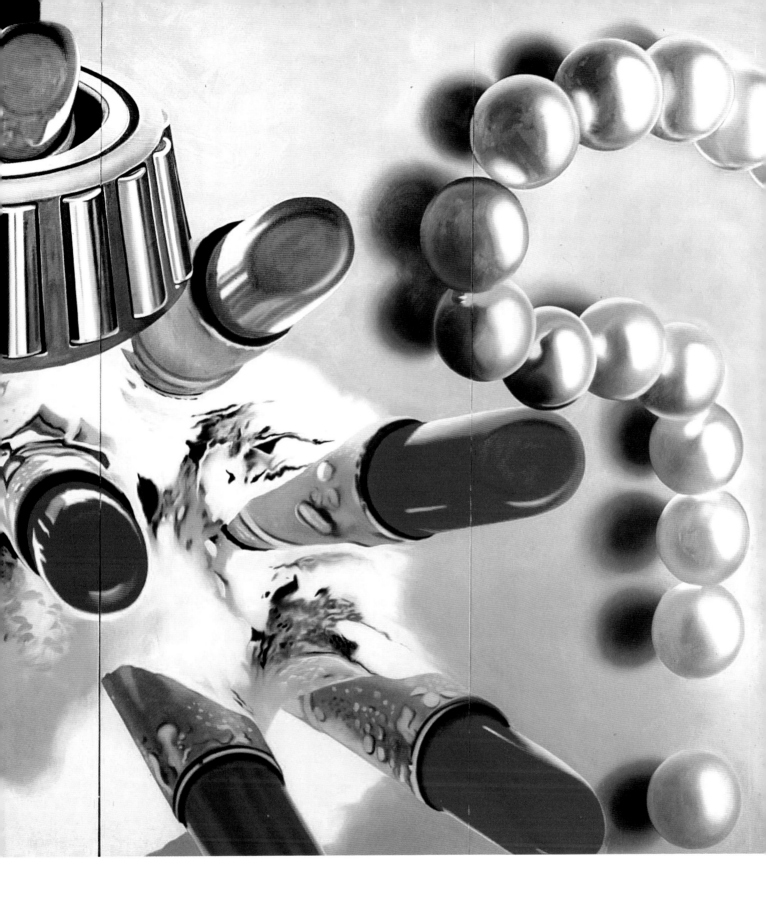

Private Collection
Oil on canvas - 205.8 x 466.1 cm

"The true work of
art is but a shadow
of the divine perfection."

Claes Oldenburg

The objects which Claes Oldenburg takes from mass production are treated with such care that they have an alienating effect, a perceptive jolt, on those who look at them. An attention to matter which the artist inherited from the Informal Art of Jean Dubuffet, without forgetting the emphatic *here and now* of American contemporaneity. Frequenting the New York social scene quickly led him to produce the most original forms, drawn from the collective imagination. Oldenburg's search goes beyond the boundaries of sculpture. Ready and packed merchandise held a particular fascination for him, a beauty which needed to be guarded and protected. And it is in matter and in its many forms that all of Oldenburg's attention is focused. "I am fond of materials which take the quick direct impress of life ... and also those materials, like flexible metal wire, which seem to have a life of their own – they hit you back if you hit them. I let the material play a significant role in the interpretation of form." Thus, as already in Roast (1961) and *Floor Cake* (1962), in the work entitled *Floor Cone* (1962), an ice cream cone is recreated, and the transfiguration of the object succeeds in stimulating genuine attraction in whoever is looking at it. Just as if one were in front of a real ice cream.

121 The artist with his wife Coosje van Bruggen.

122-123 Claes Oldenburg was born in Stockholm on 28 January 1929; he lives in New York.

125 **Rotten Apple Core, 1987**
(Claes Oldenburg and Coosje van Bruggen) Hamburger Kunsthalle, Hamburg Canvas, polyurethane foam, steel; coated with resin and painted with latex - 165.1 x 121.9 x 121.9 cm.

Oldenburg's foods are those on the menus of the cafés in the Mnahattan's Fourteenth Street and the low-cost delicatessens of Second Avenue: sandwiches, hamburgers, slices of chocolate cake. In this sense, Oldenburg's approach becomes human without being sentimental.

In the *Home* series, the furniture displayed by Oldenburg, on the other hand, expresses a vulgar, tasteless luxury. *Bedroom* (1964) is a space in which we see a bedroom in perspective: walls covered with mass produced abstract layers and white sheets which contrast with the finishings in striped material, create an alien and suffocating atmosphere.

The *Soft Objects* are among his most unashamedly Pop creations. These are objects made from shiny vinyl, which change shape when touched. Oldenburg's humanity derives in part from his attraction to real life. His art stems from the metropolis, its language and the people who live there. His tones are ambivalently affectionate and critical toward the subjects he tackles. Like life, they conceal bitterness and sweetness, stupidity and desire.

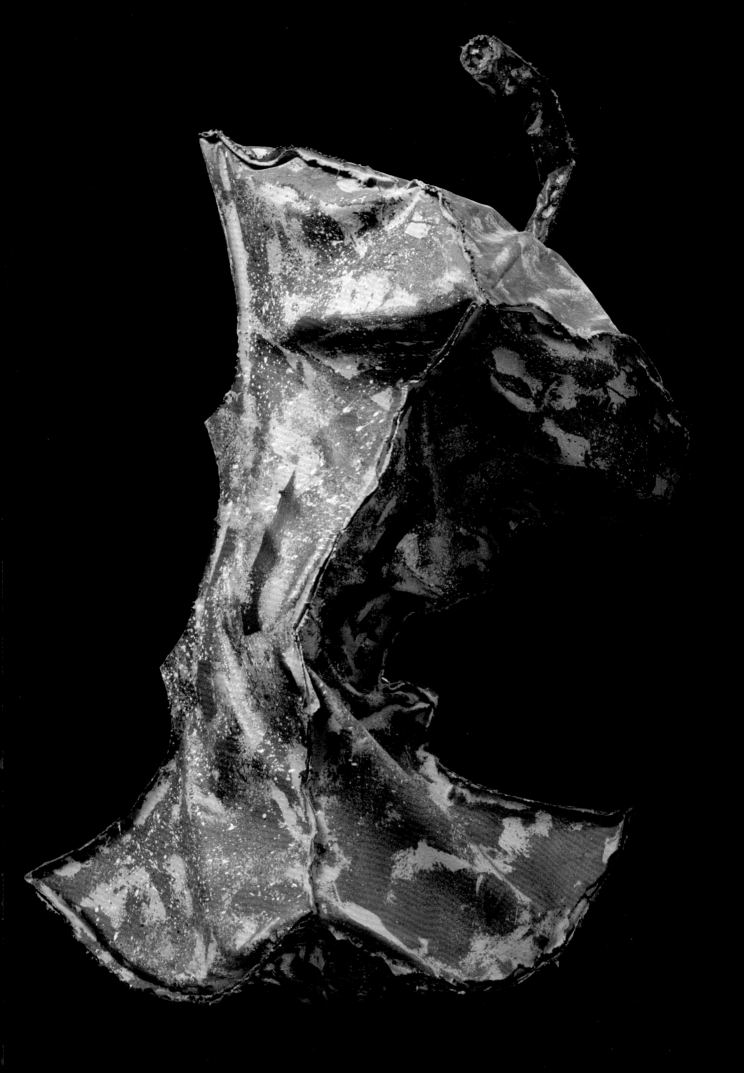

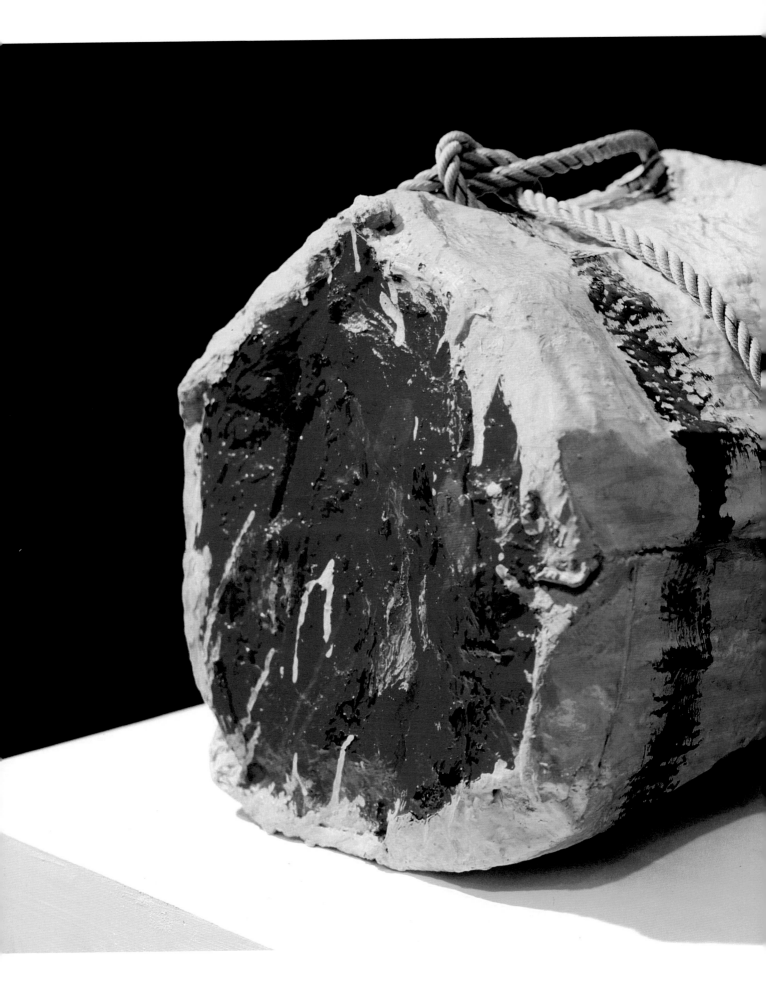

ROAST, 1961

Museo di arte moderna e contemporanea
di Trento e Rovereto (MaRT) - Sonnabend Collection
Muslin soaked in plaster over wire frame, painted
with enamel, with rope - 35.6 x 43.2 x 40.6 cm

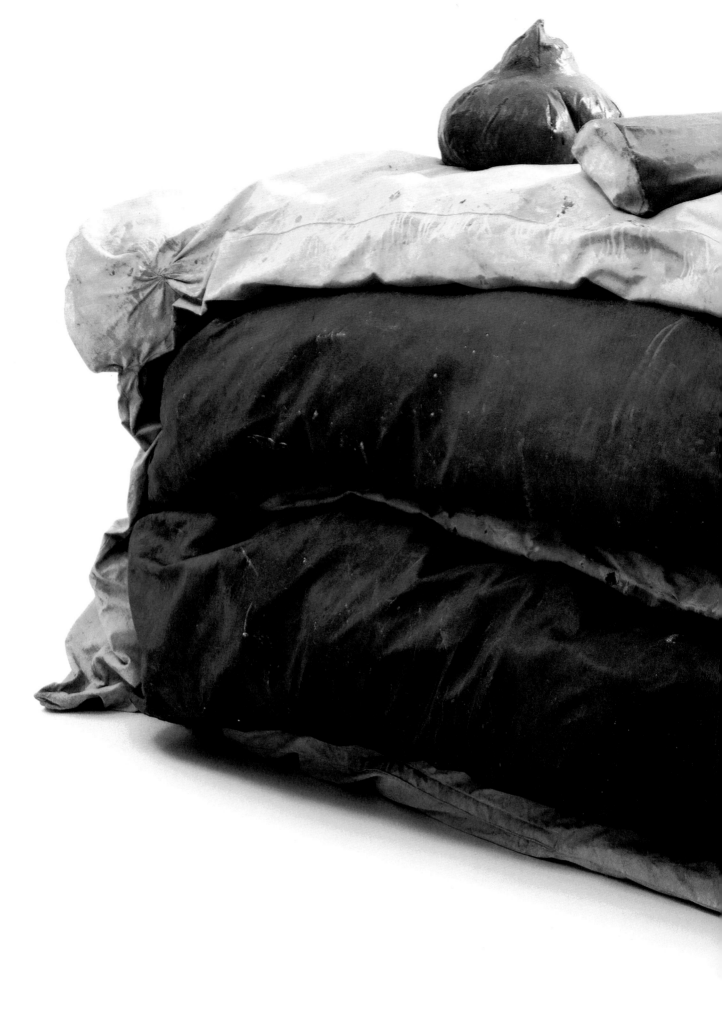

Two Cheeseburgers, with Everything (Dual Hamburgers)

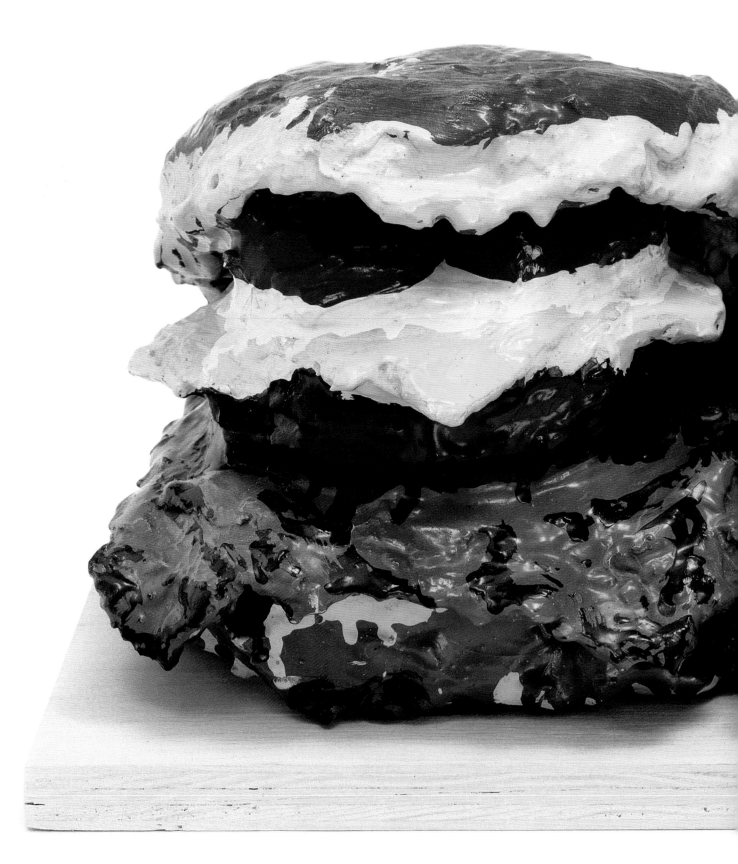

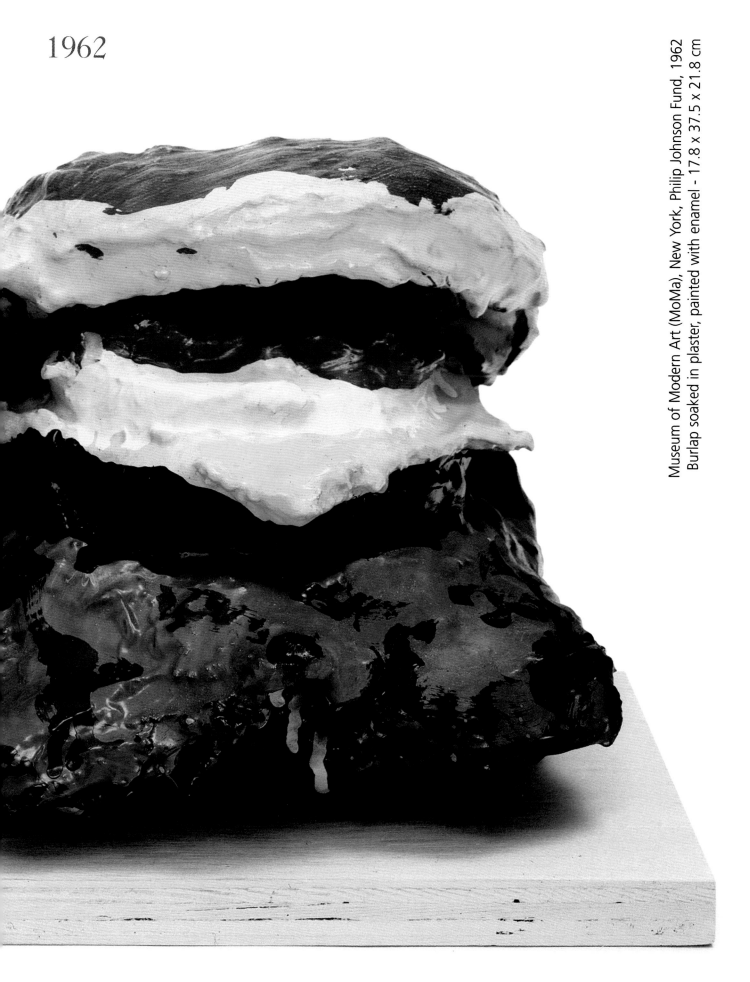

Museum of Modern Art (MoMa), New York, Philip Johnson Fund, 1962
Burlap soaked in plaster, painted with enamel - 17.8 x 37.5 x 21.8 cm

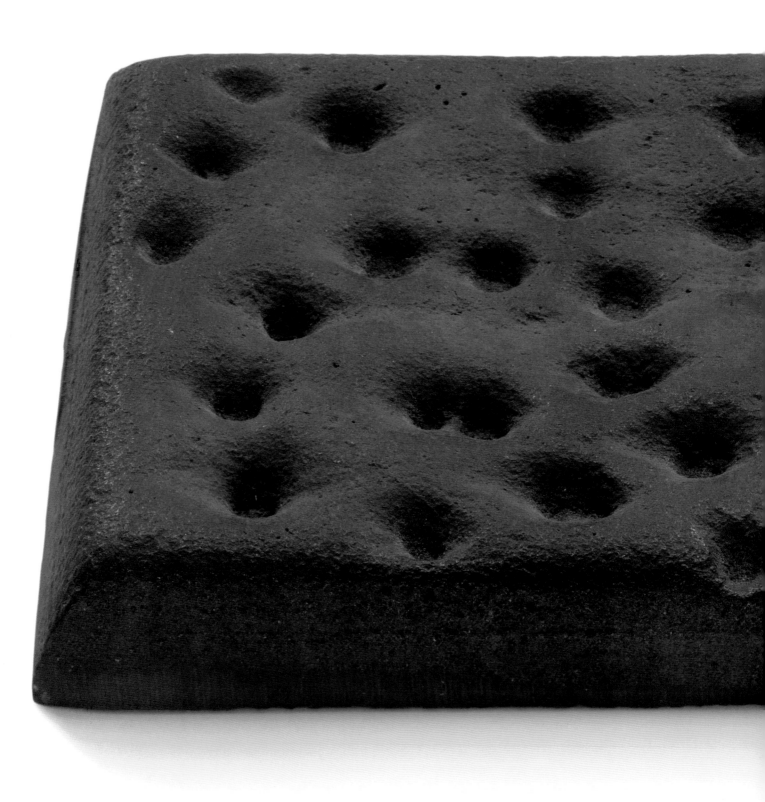

1966

Museum of Modern Art (MoMa), New York
Cast iron - 16.5 x 9.5 x 1.9 cm

"I don't deal exclusively with
the popular image.
I am more concerned with
it as part of my landscape."

Jim Dine

His grandfather was an ironmonger and once Jim Dine admitted that having worked in the family shop for years had deeply influenced his work. Hammers, saws, nails, pieces of pipes, frequently appear in his work, a direct path from experience to art: the objects themselves applied to the canvas with different techniques, or their painted two-dimensional reproductions.

This is essentially at the center of Dine's work: a continuous interplay between what is real and its representation, aimed at re-defining Art with respect to reality. "People confuse this social business with Pop Art," he once said.

"Well, if it's art, who cares if it's a comment?" Even though this statement sounds decisively Pop, many doubted whether he belonged to this movement, and looked for other frames of reference to describe his work.

The most convincing interpretations see Dine as an artist who is a group on his own: his art is a parody of Abstract Expressionism, of which he emulates the action and techniques in order to submerge them in his own poetry, where we find the vast range of tools and instruments already mentioned above.

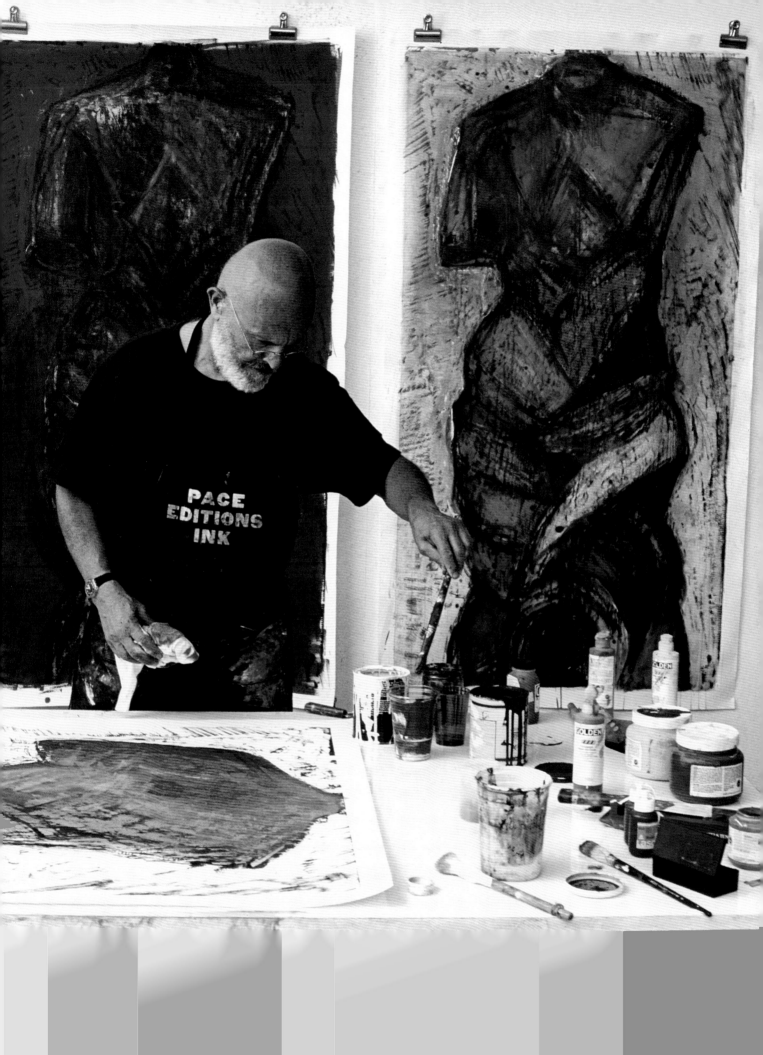

137 Jim Dine was born in Cincinnati on 16 June 1935; he lives in New York and Putney (Vermont).

139 **Putney Winter Heart n° 3 (Garbage Can), 1971-72**
Musée National d'Art Moderne - Centre Pompidou, Paris
Mixed media - 183 x 183 cm.

Also evident and often highlighted are the surrealist innuendoes, easily traced to objects which recall Magritte (real taps with painted drops of water) or in the interplay of shadow and light as in Man Ray. Others prefer to trace his work back to New Dada: as Lawrence Alloway wrote, the objects he used were not "bought fresh."

Jim Dine's works have been exhibited in the most important galleries associated with Pop and Dine himself often features in significant events and exhibitions that are considered to be instrumental in the foundation of this style.

However, it has been affirmed that interpretation of daily objects in Pop subjects and aesthetics has made Dine one of its most original exponents. The bathrobes, the sneakers, the palettes, the stereotyped shapes – above all the hearts – are transfigured by color, by the unpredictable mark of his brushes, rather than displayed in their serial impersonality. "I'm working on a series of palettes right now. I put down the palette first, then within the palette I can do anything – clouds can roll through it, people can walk over it, I can put a hammer in the middle of it..."

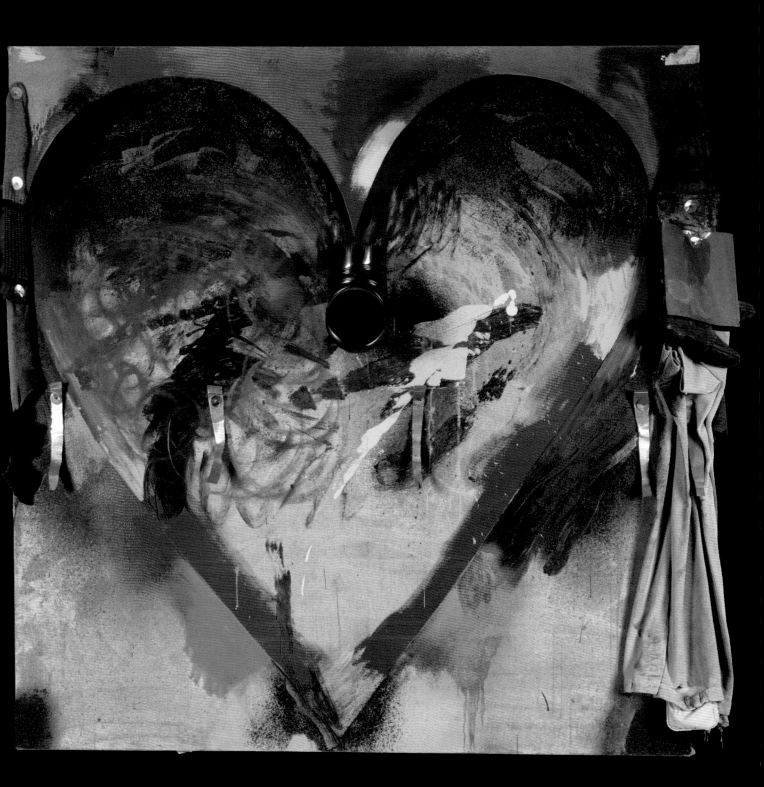

CAR CRASH, 1959-60

Private Collection
Oil and mixed media on burlap - 152.4 x 160 cm

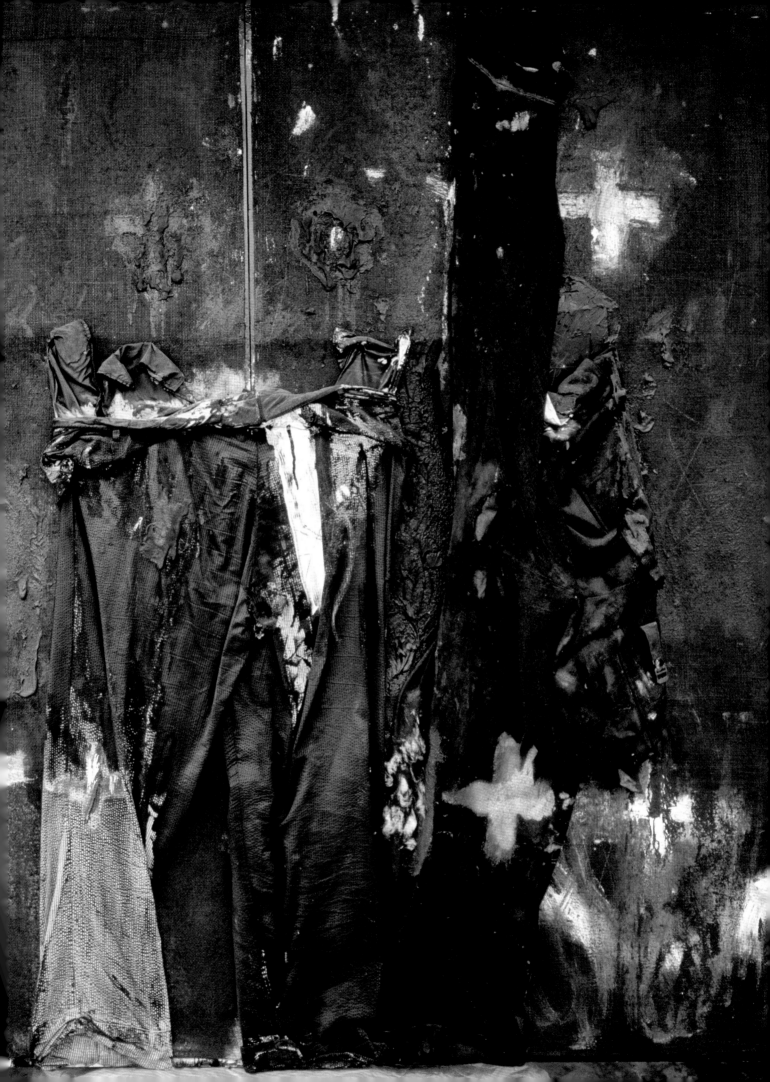

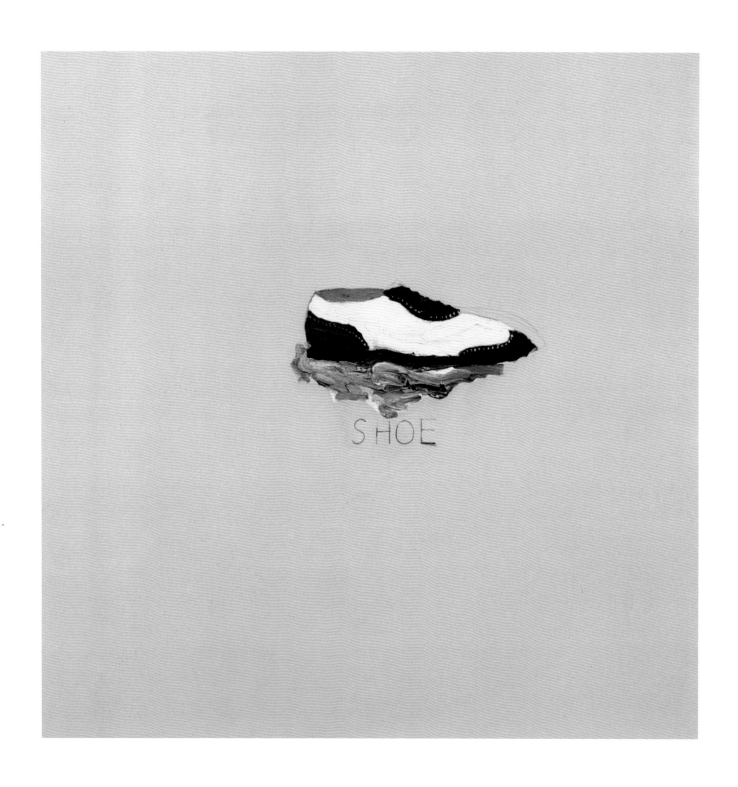

SHOE, 1961

Ileana and Michael Sonnabend Collection, New York
Oil on canvas - 164 x 142 cm

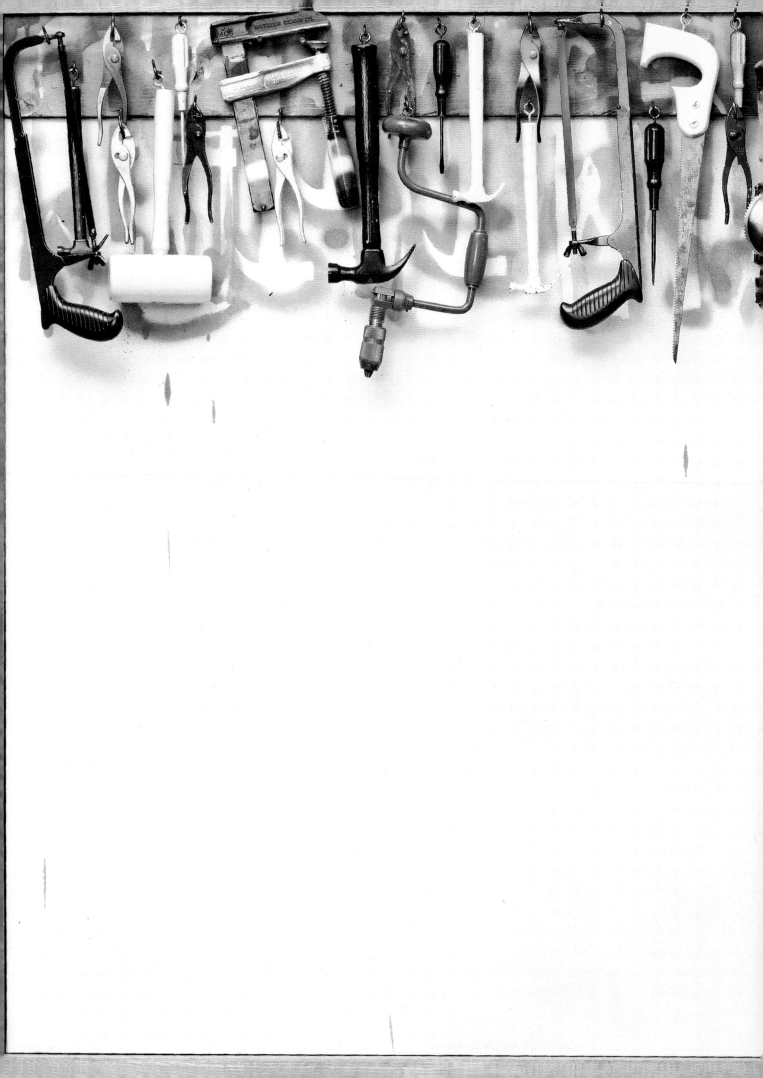

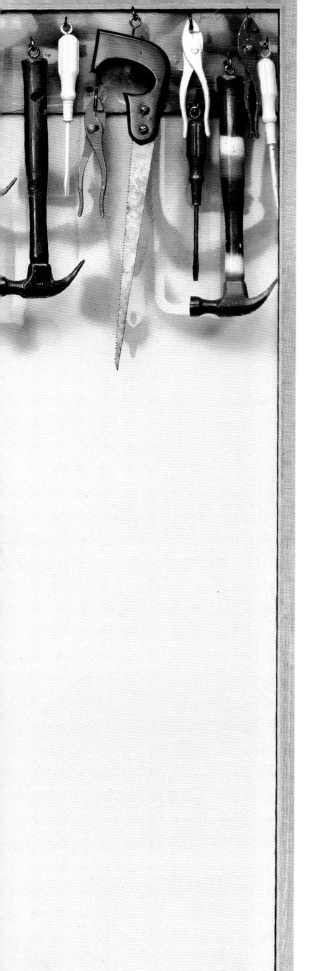

FIVE FEET OF COLORFUL TOOLS, 1962

Museum of Modern Art (MoMa), New York

Oil on unprimed canvas surmounted by a board on which painted tools hang from hooks - 141.2 x 152.9 x 11 cm

1975

THE WOODCUT BATHROBE

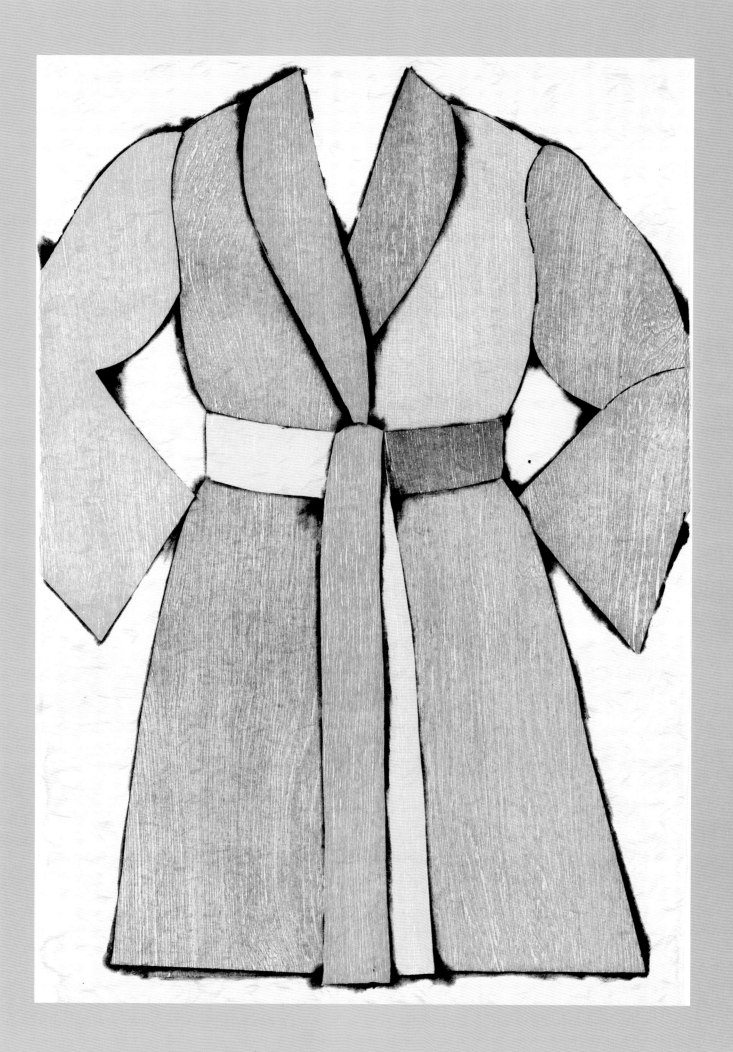

"I've always been fascinated by numbers.
Before I was seventeen years old,
I had lived in twenty-one different houses.
In my mind, each of those houses had a number."

Robert Indiana

Artist, art director, cos-tume designer, Robert Indiana was born in New Castle, in the state of Indiana and moved to New York in 1954. Being more detached from the formal beliefs of the other Pop artists, his approach is an interpretation of Pop Art which tended toward Abstract Art, of which Indiana remains one of the greatest exponents. Indeed, his works are a collection of literary suggestions – quotations and romantic invocations – put together along geometric lines which recall pinball machines and road signs. When we look away from the writing, what remains are simple regular forms, which can be traced to technologicalmachinery, that is to say figures which are absolutely not objective.

Eat and *Die* (1962), two panels produced with the oil technique, demonstrate the vigor of the red and the black backgrounds and that of the writing, which stands out like a warning on the canvas surface. In *God is a Lily of the Valley* (1961), the writing *God is a tiger, is a star, is a king, is a ruby, he can do everything but fall* is a quotation taken from a spiritual.

In Indiana's work, much more so than in other Pop works, one perceives strong criticism of the United States and social injustice, mixed with an extreme existentialism as in the case

of Alabama (1965) where the events of Selma (Alabama) are strongly criticized with the writing *Just as in the anatomy of man, every nation must have its hind part*. It was in Selma that racial problems exploded following demonstrations for the right to vote.

The series *Poetic Sculptures* was created during a later period. Without abandoning his romantic yet sharp streak, the artist began to put together writing using larger dimensions and making it tri-dimensional. This applies to *LOVE*, the sculpture which made him famous with the general public, which is in the shape of a square with the letter 'O' placed obliquely with respect to the other letters. This work, produced in 1964, was used, years later, in an 8-cent stamp, the first of the commemorative stamp series, *Love Stamps*.

151 Robert Indiana was born in New Castle (Indiana) on
13 September 1928; he lives in the island town of Vinalhaven (Maine).

153 **The Figure Five, 1963**
Smithsonian American Art Museum, Washington, D.C. Oil on canvas - 152.4 x 127.2 cm.

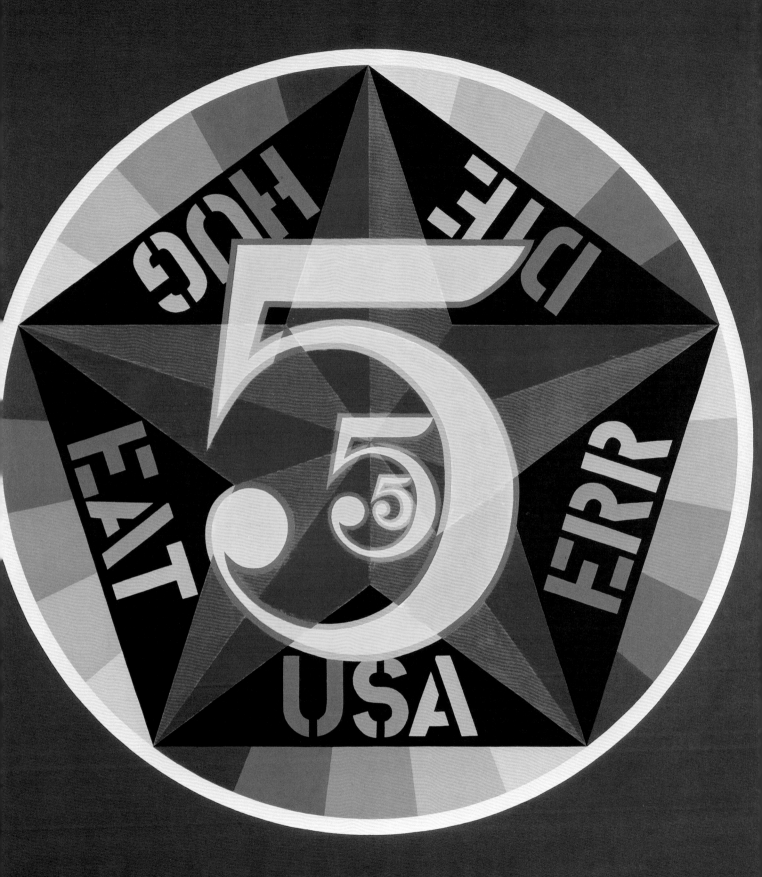

THE FIGURE 5

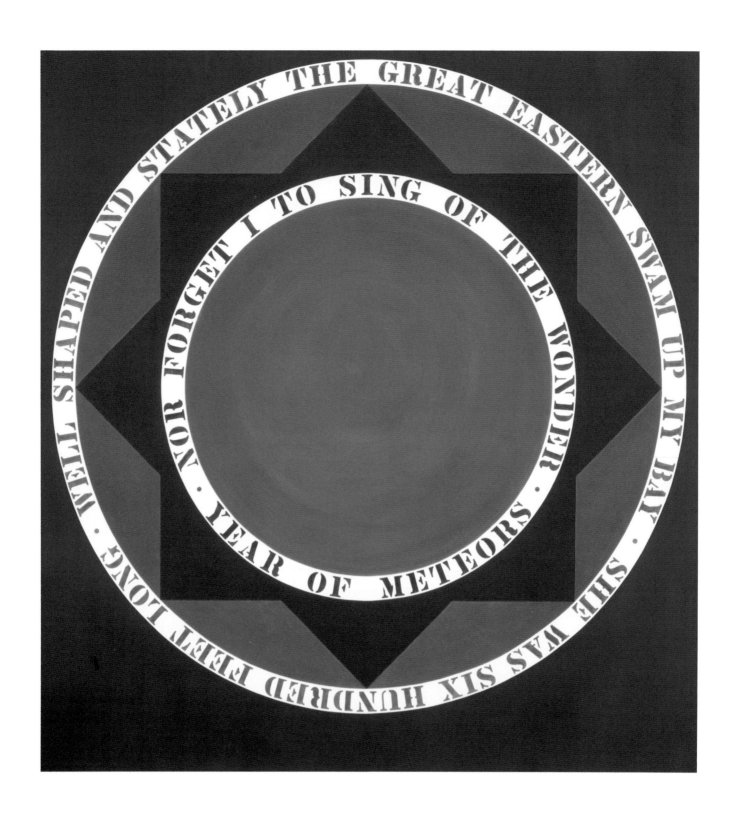

Year of Meteors, 1961

Albright-Knox Art Gallery, Buffalo - Oil on canvas - 228.6 x 213.36 cm

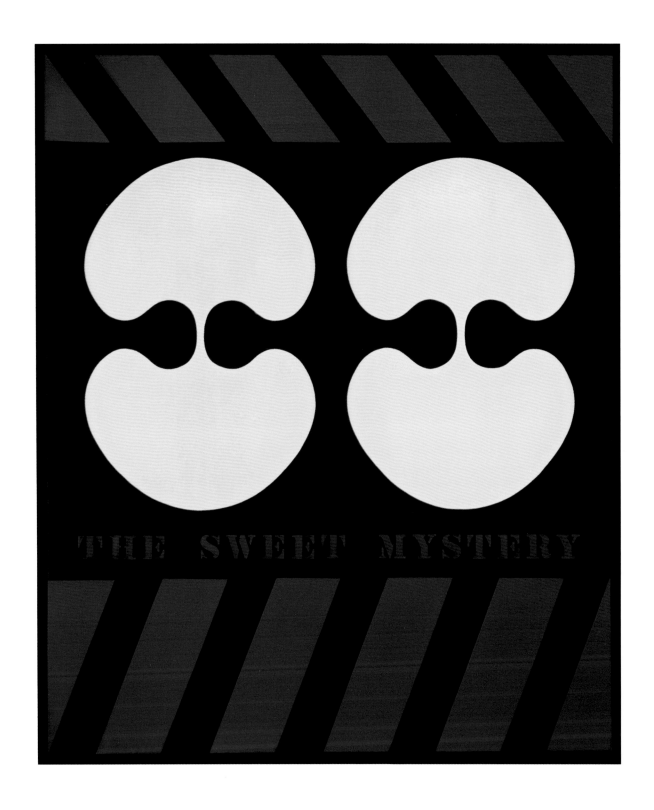

THE SWEET MYSTERY, 1960-61

Private Collection - Oil on canvas - 182.8 x 152.4 cm

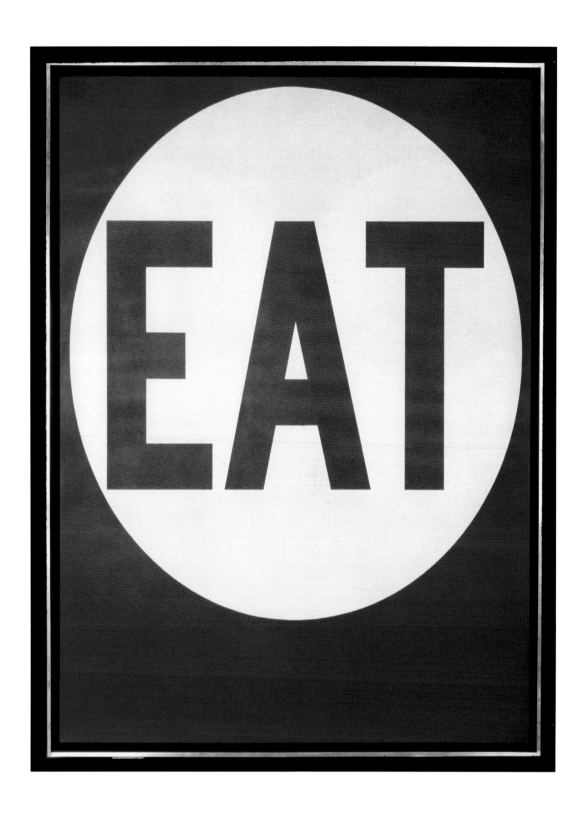

Eat/Die, 1962

Private Collection
Oil on canvas - Two panels,
each 182.8 x 152.4 cm

DIE

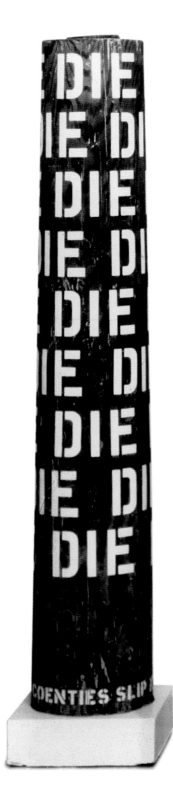
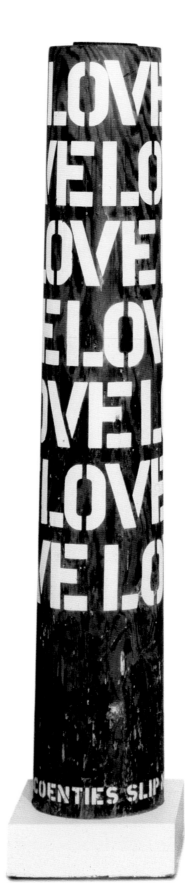
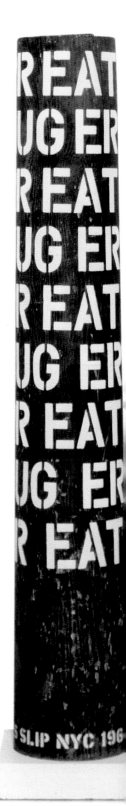

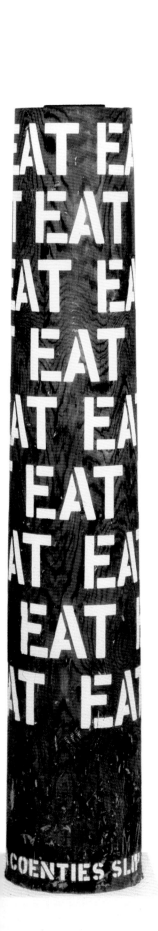
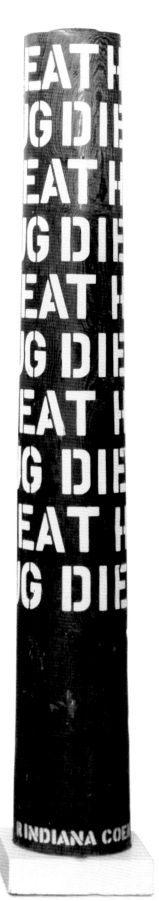
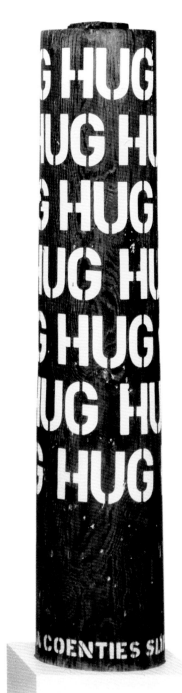

COLUMNS, 1964

Private Collection - Plaster on wood - Maximum height ca. 200 cm

LOVE, 1967

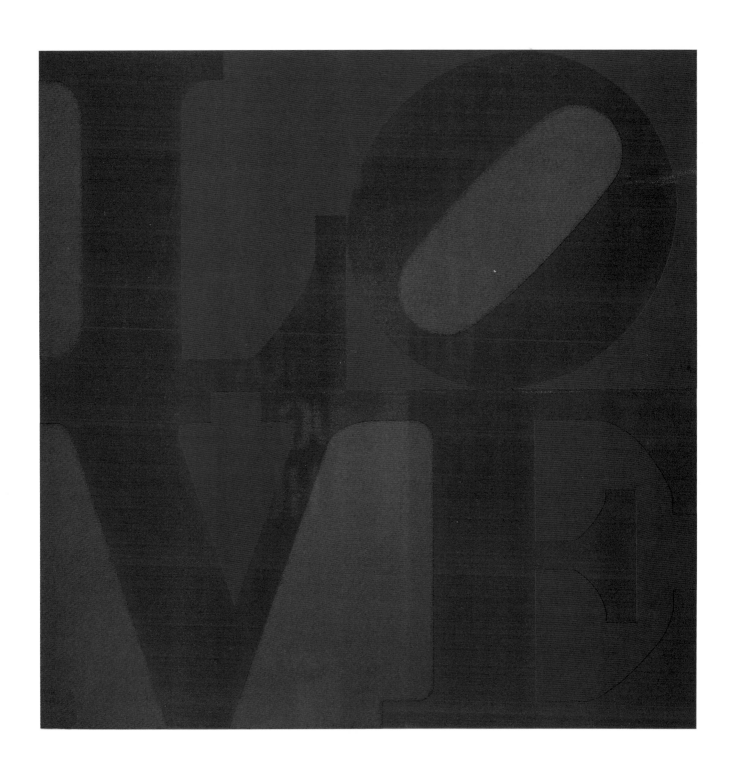

Museum of Modern Art (MoMa), New York
Screenprint - 86.3 x 86.3 cm

LOVE, 1964

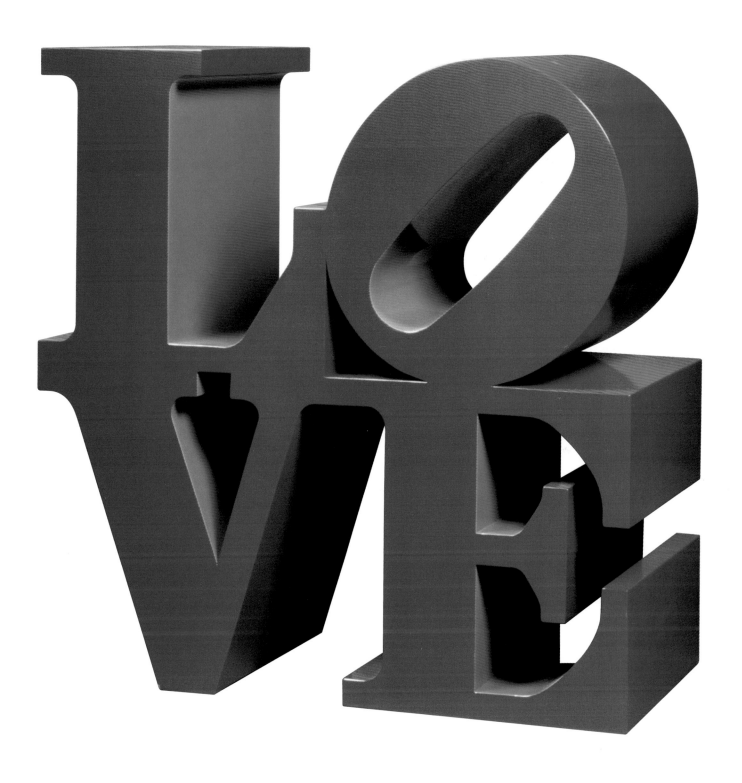

Private Collection
Polychrome aluminum - 91 x 91 x 46 cm

"Even though the museums guarding
their precious property fence everything off,
in my own studio, I made them so you and
I could walk in and around, and among these sculptures."

George Segal

"If you couldn't sell big pictures, how will you be able to sell enormous sculptures?" This is what Helen, the artist George Segal's wife said. Segal always reacted with resignation to this sort of statement, but he decided that he would continue to do what interested him and continue to sell nothing. His job as a secondary school art and design teacher – he said – was enough to live on and as even the attempt to keep chickens had failed miserably, he would fill his farm with unsold works which only he liked.

He came from a humble family and it was said that George Segal carefully observed normal every day actions of normal people: shaving, having a coffee, sitting at a table, walking along a street. Silent figures, in an off-white color, performing these insignificant actions: life size statues have nothing realistic about them at the surface but inside they preserve the mold of a real body. This is how Segal made most of his sculptures: by covering his wife's body and that of friends and acquaintances with bandages and plaster. His work freezes moments of life, and always displays a slightly sad look at humanity, and is surrounded by a hue which distances Segal from Pop's typical humor.

It was his close friendship with Allan Kaprow which

brought him closer to this style, the fact that his farm

was the location of a historic happening (1960) and also

the fact that his human figures were often accompanied by

absolutely ordinary and real objects. Two symbolic examples

are the woman sitting at a yellow table in the very famous *The*

Restaurant Window (1967) and the one depicted washing her feet

in a real ceramic sink (*Woman Washing Her Feet in a Sink*, 1964-65).

In general, if Pop Art was interested in things associated with people,

at the center of Segal's work there are precisely the people themselves,

narrated through their routine movements and moods.

165 George Segal was born in New York on 26 November 1924 and died in New Brunswick (New Jersey) on 9 June 2000.

167 **Portrait of Sidney Janis with Mondrian Painting, 1967**, Museum of Modern Art (MoMa), New York, Plaster figure with Mondrian's "Composition," 1933, on an easel 177.3 x 142.8 x 69.1 cm.

168-169 **The Depression Breadline (detail),** Franklin Delano Roosevelt Memorial, Washington, D.C., 1997 (bronze).

170-171 **Artist in his Loft, 1969**, (plaster, wood, metal, glass, porcelain), and **Girl Putting on Mascara, 1968**, (plaster and wood) from an exhibition at the Hamburger Kunsthalle, Hamburg.

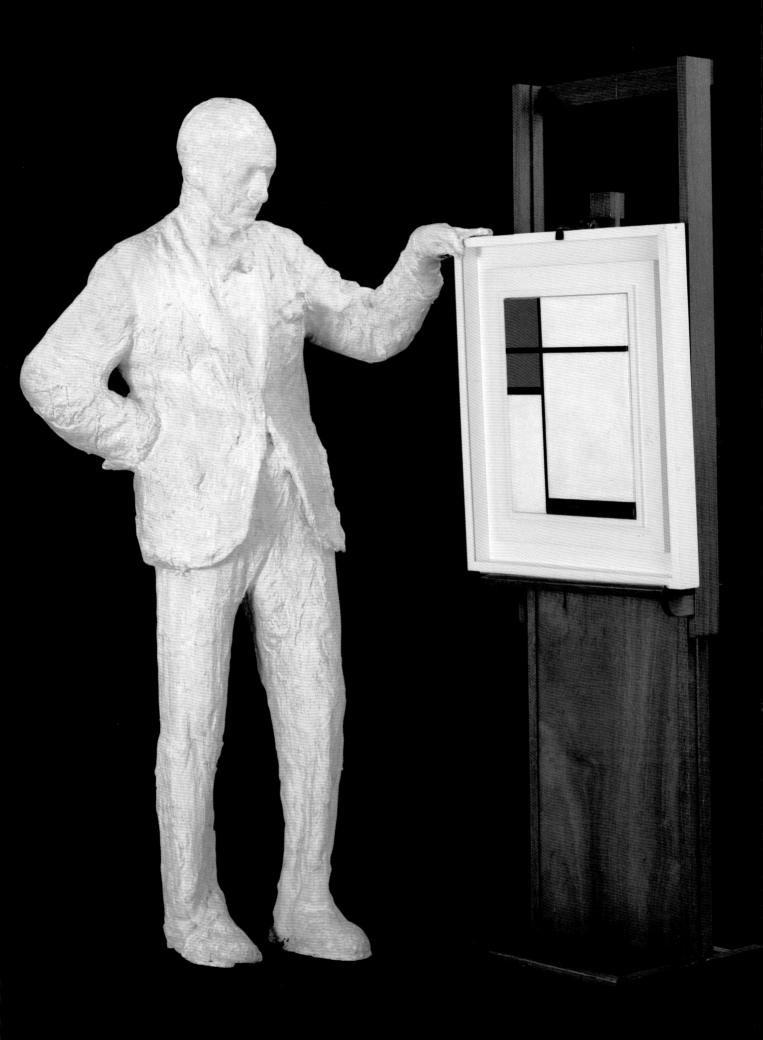

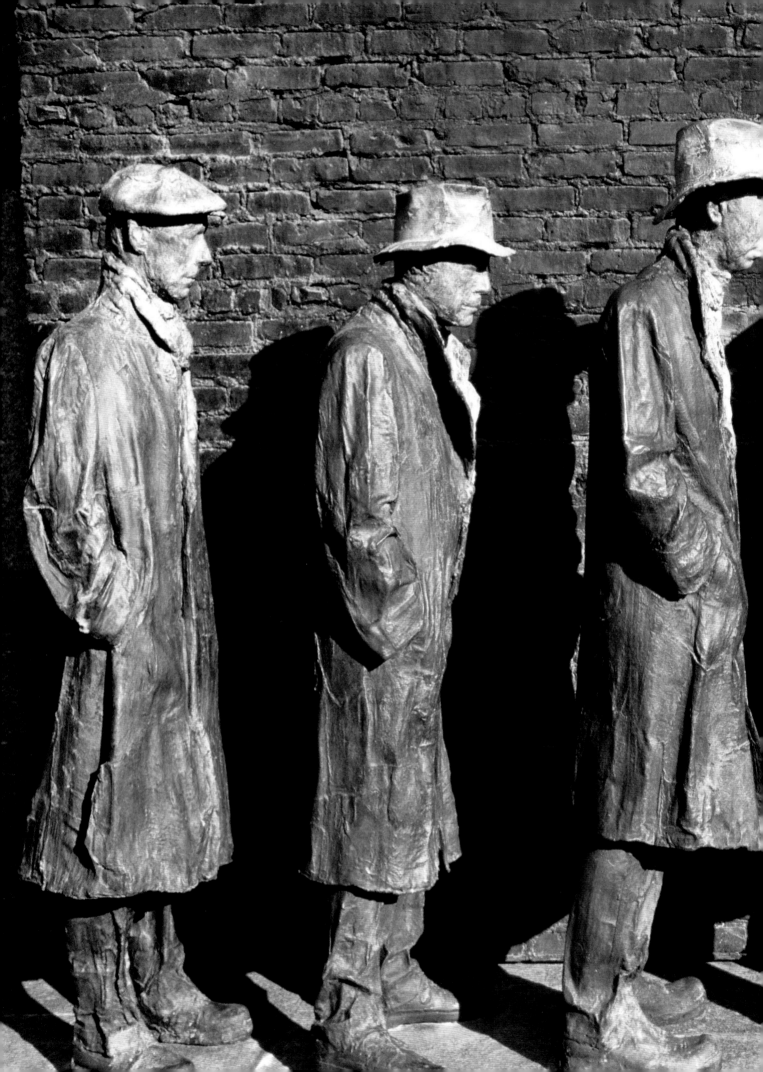

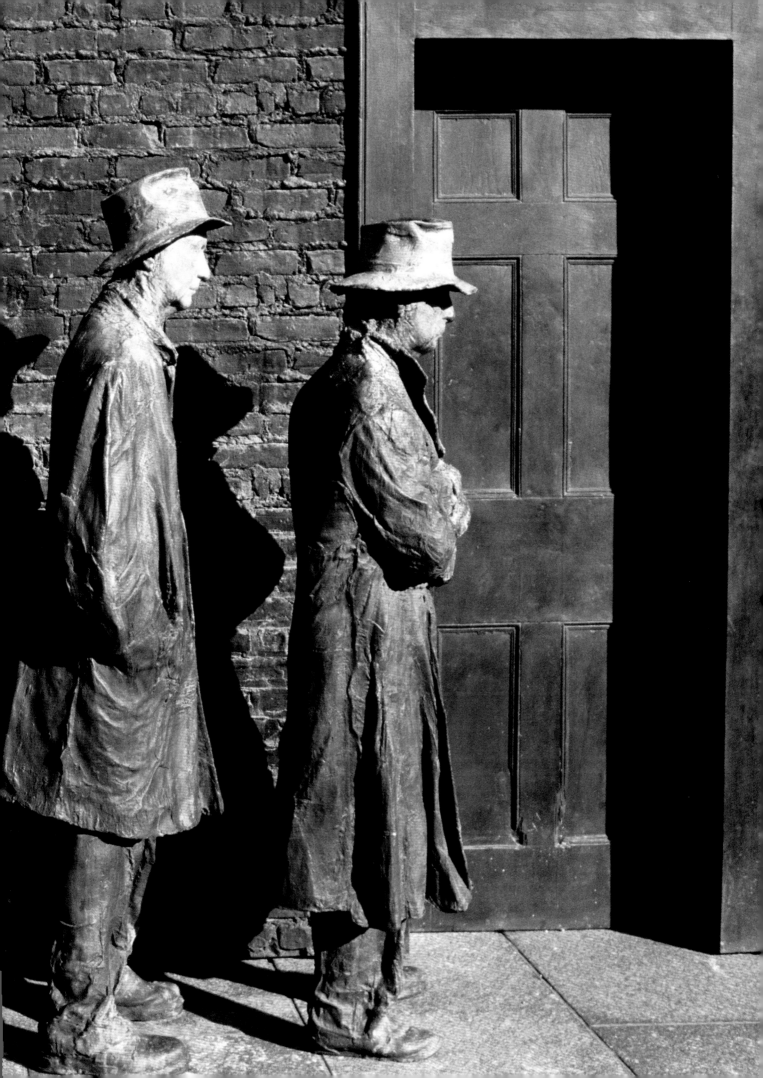

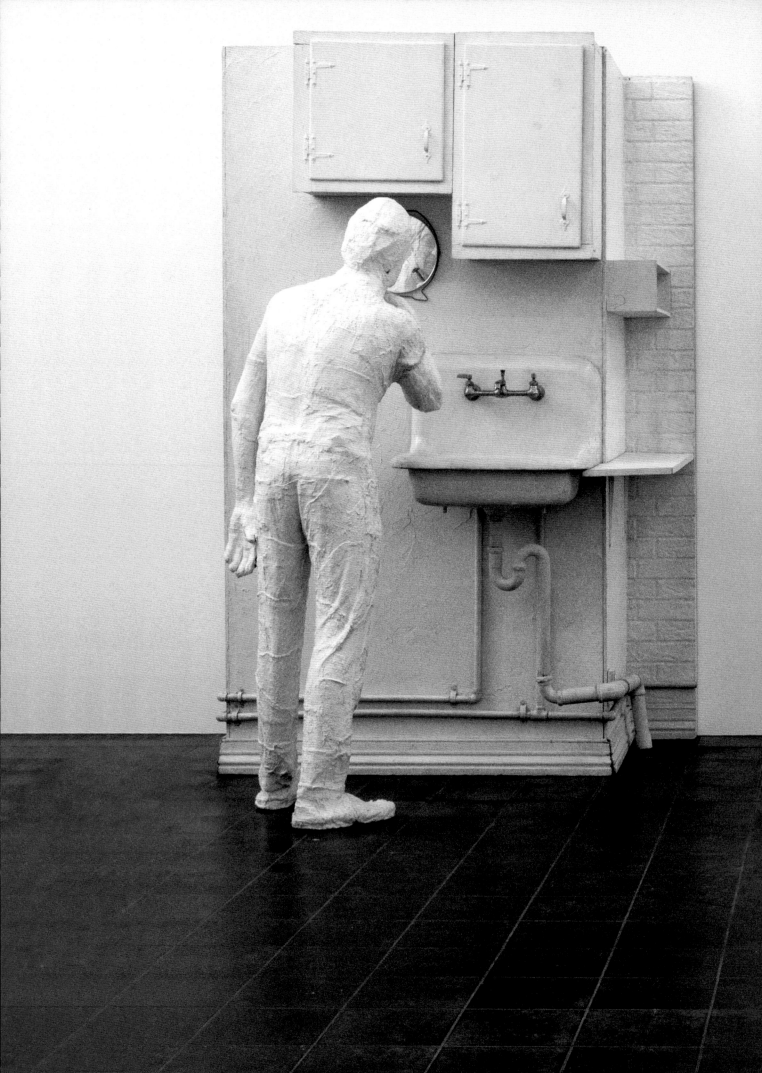

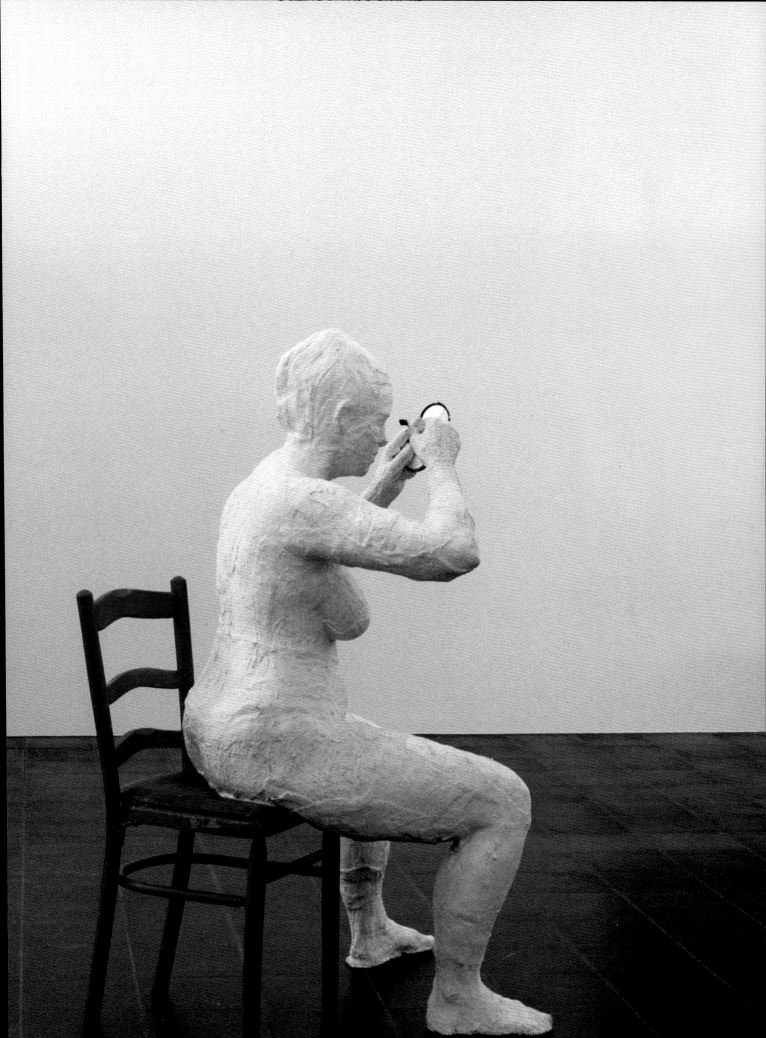

BUS DRIVER, 1962

Museum of Modern Art (MoMa), New York
Figure of plaster over cheesecloth; bus parts including coin box, steering wheel,
driver's seat, railing, dashboard, etc. - 226 x 131 x 195 cm

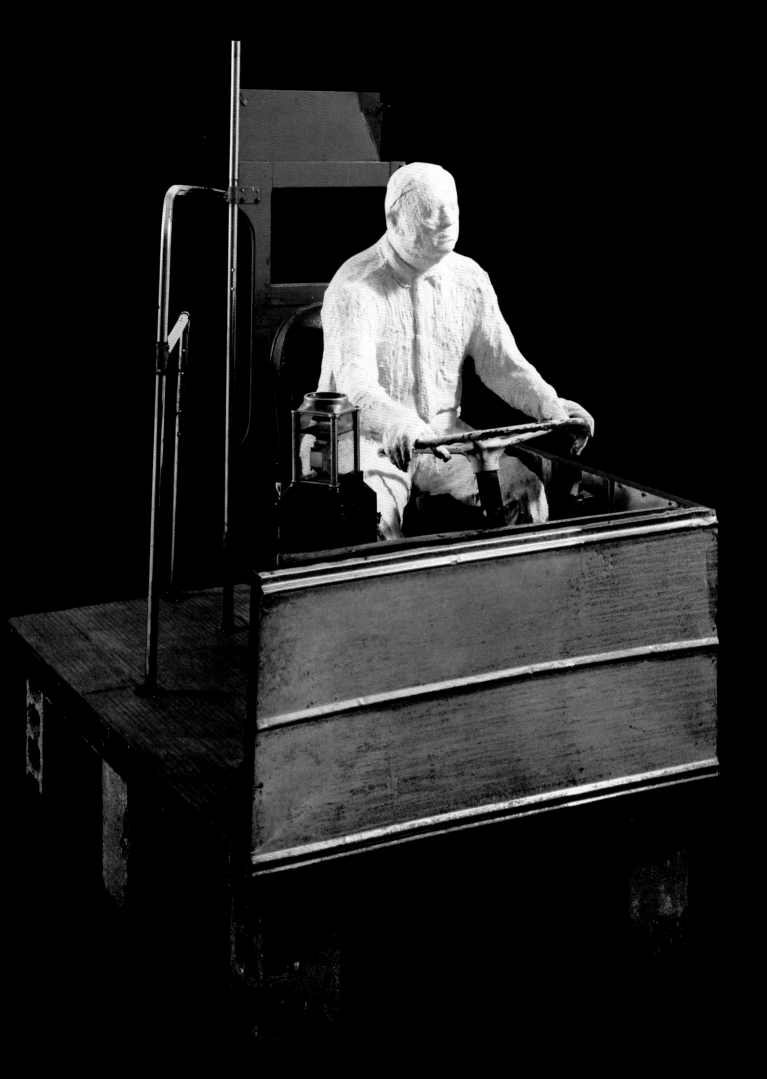

Ed Ruscha

TWENTYSIX GASOLINE STATIONS

Twentysix Gasoline Stations (1963) and *Every Building on the Sunset Strip* (1966): are two artist's books, two unforgettable and unique pieces of American art. There is a profoundly Pop universe in Edward Ruscha's work, but there is also a sweet irony and a little melancholy. Born in Omaha, in Nebraska, he moved to Los Angeles and entered the art scene at the end of 1950: in one of his writings, "Okie," he says that he moved west to study graphic design at the Chouinard Art Institute and to partake in the Los Angeles lifestyle which he had long admired from afar. He soon discovered that he was a painter and not a designer.

His painting, initially strong and dense, close to Abstract Expressionism, became little by little colder; it lost its movement and became clean, almost surgically clean. He seems to be searching for an air-tight and frozen stylistic perfection which draws from ordinary situations – from what is seen on the road, from what is on road-side billboards – creating images which are often removed from reality and live in a suspended, and enigmatic atmosphere.

It happens with gas stations – painted in a rigid and dry perspective which make them familiar and alienating at the same time, in a truly simultaneous fashion – it happens with the

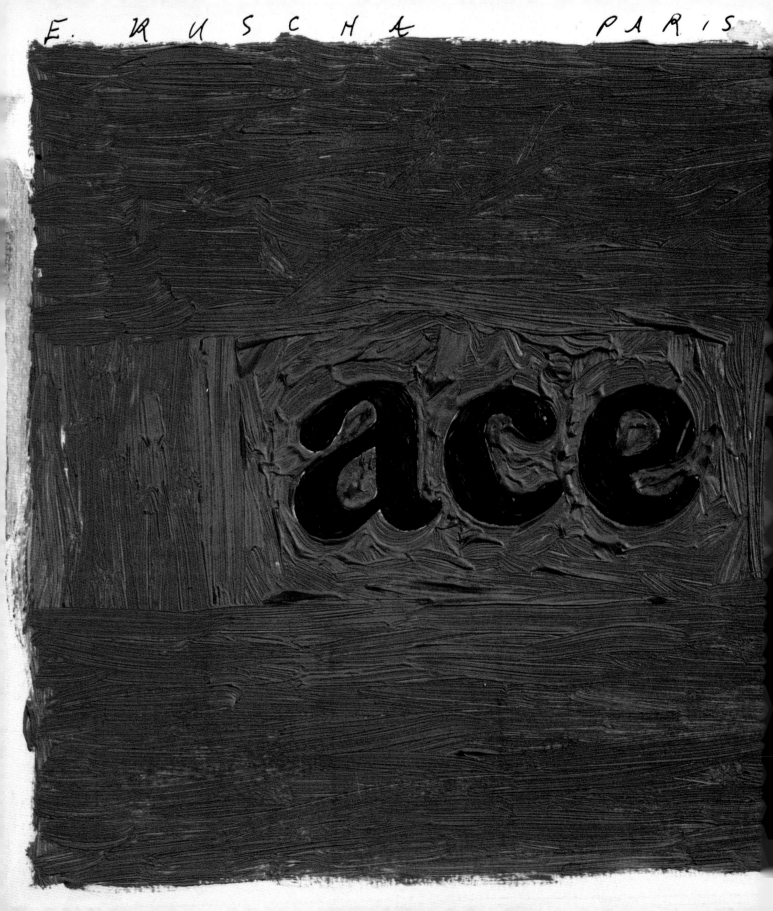

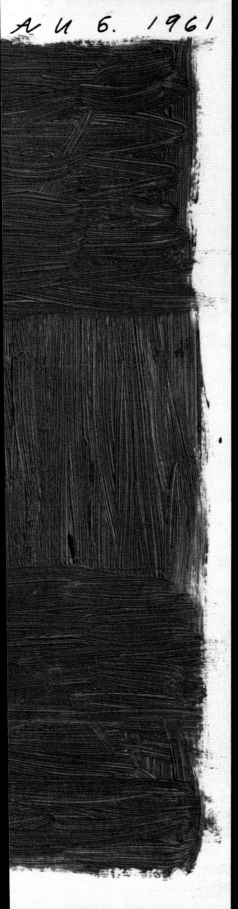

A U 6. 1961

writings taken from goodness knows where, recurring words, Pop words – "BOSS," "RADIO," "HOLLY-WOOD" – which could be anywhere but which certainly in Ruscha's painting are steeped with new meaning. It also happens with photographs, the many photographs which Ruscha takes: like other Californian Pop artists, he does not seek faithful reproduction of ready-made images but prefers, with every possible means of expression, to invent his own, ironic commercial iconography. If toward the mid 60s the New York Pop scene eclipsed the Californian exponents by way of reviews and overall success, according to many people it is precisely here that Pop was born: on the motorways, the gas stations, in film studios, the logos, the palm trees, the swimming pools which Ruscha was first to put at the center of his work, treated with brush strokes and pencil marks, and with the dashes and sketches drawn with cotton Q-tips.

177 Ed Ruscha was born in Omaha (Nebraska) on 16 December 1937; he lives in Los Angeles.

178-179 **Ace, 1961**
Collection Robert Rauschenberg Foundation, Captiva - Oil on paper - 18.4 x 22.2 cm.

Oof, 1962

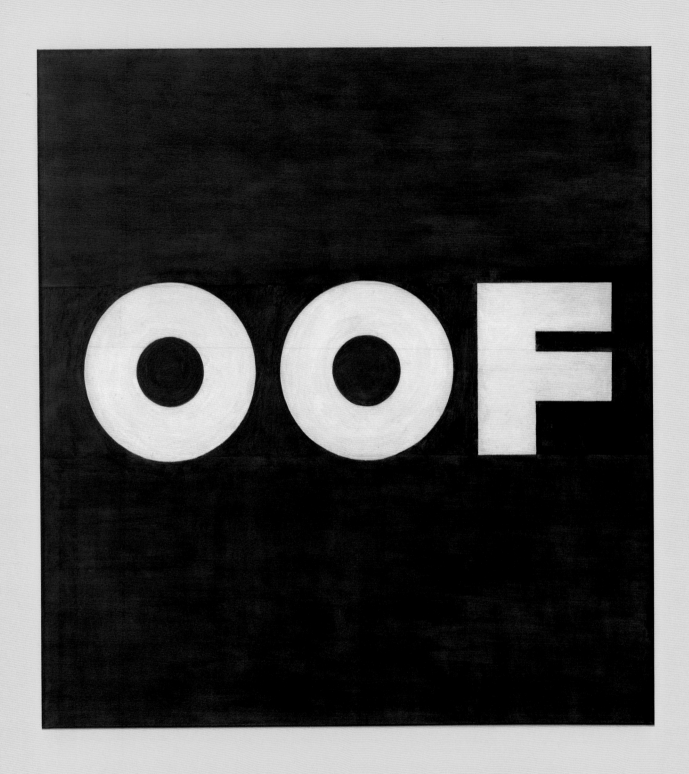

Museum of Modern Art (MoMa), New York
Oil on canvas - 181.5 x 170.2 cm

DYNAMICS OF THE BRAIN, 1984

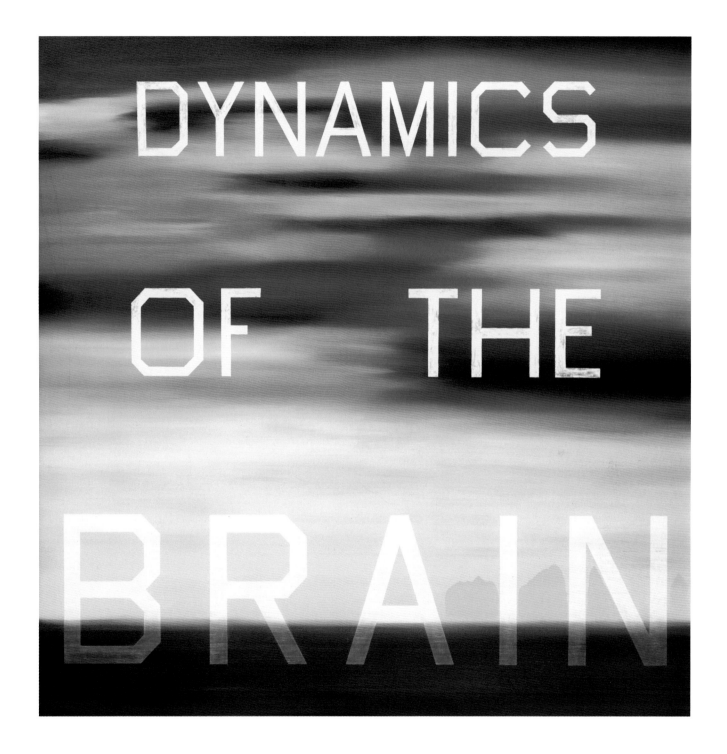

Albright-Knox Art Gallery, Buffalo
Oil on canvas - 162.56 x 162.56 cm

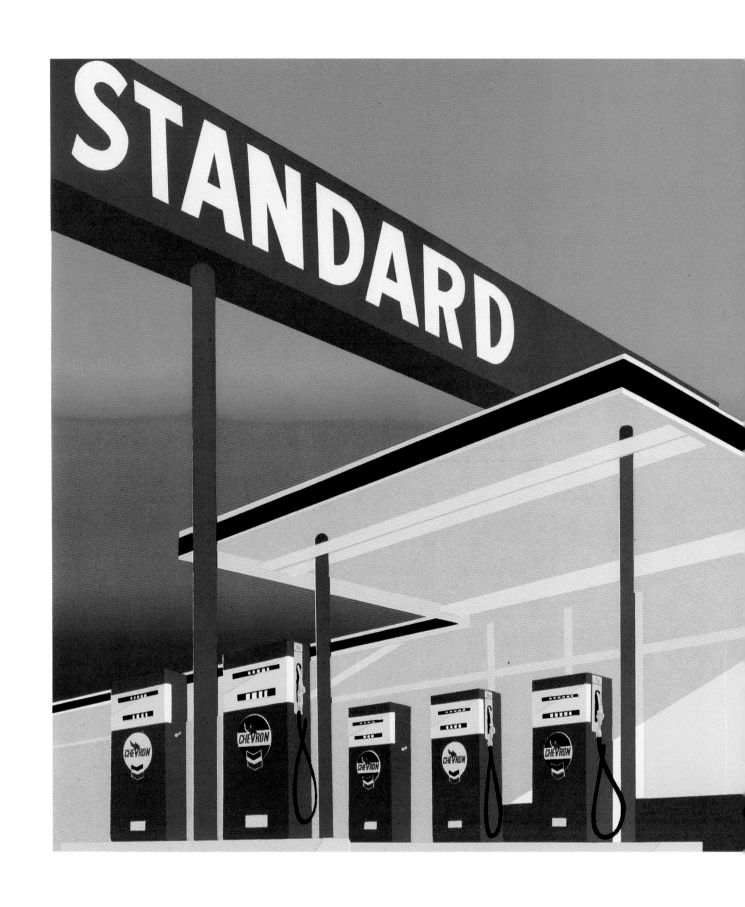

STANDARD STATION, 1966

Museum of Modern Art (MoMa), New York
Screenprint - 49.6 x 93.8 cm

Museum of Modern Art (MoMa) - New York
Gouache, cut-and-pasted paper, charcoal, and pencil on paper
17.5 x 55.5 cm

"I try to work every day,
even when I'm not motivated.
Ritual is very important to me."

Mel Ramos

At the same time as the New York Pop Art scene was at its height, other artists on the Pacific Coast were using the language of *Pop Culture* with the same energy and commitment, activating a series of interesting relationships in contexts which, in the 50s, had already been fertile ground for the development of beat culture. At the beginning of the 60s, Ramos made his debut with an elegant style of painting depicting solitary figures with thick, paint-heavy brush strokes, pasted on black and white backgrounds. But shortly afterwards, fascinated by Hollywood and by the proliferation of supermarkets lit up with neon signs as bright as day, he embarked on a new path. Together with Ed Ruscha and even before that with Edward Kienholz, he thus became the one of the most significant exponents of the Californian Pop movement. The artist, obsessed by image, accomplished a work of total de-contextualization, elevating to the status of real icons some items that form an integral part of American culture. Cartoon heroes and voluptuous pin-ups, depicted with deliberately artificial colors, modeled on examples from the press, from posters, and from pornographic magazines. The intention is to celebrate well-known characters, while using a dry and aseptic style, based on the primary composition of colors on the flat surfaces of the canvas.

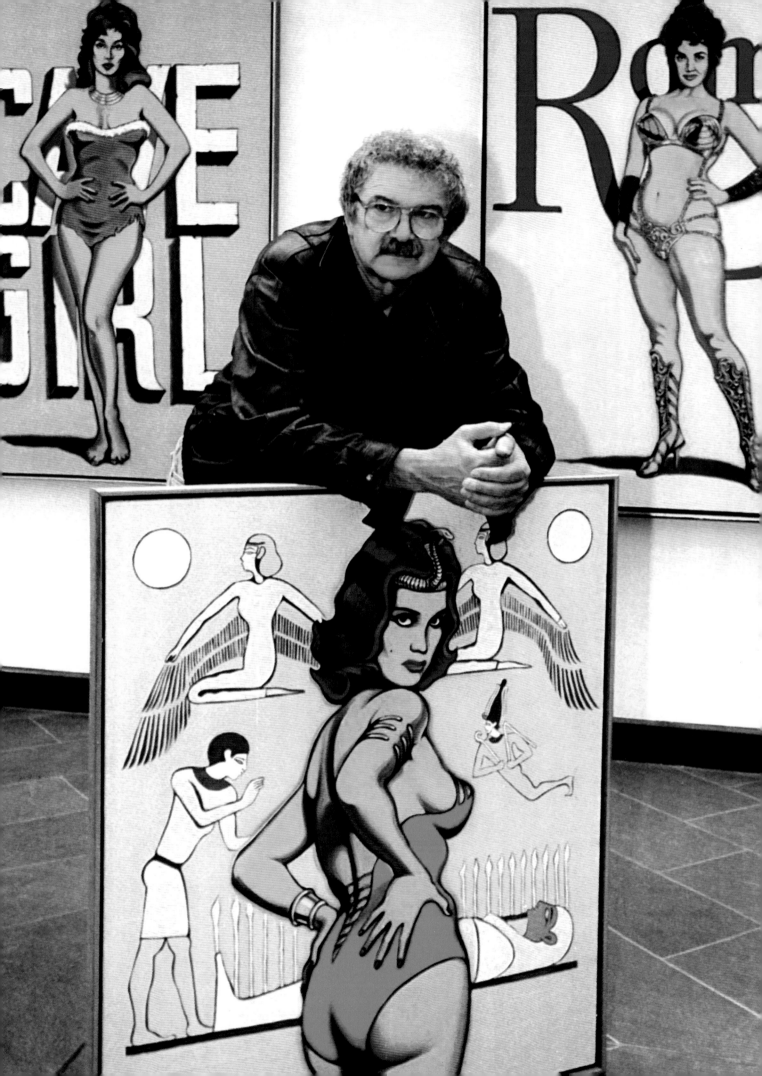

Initially, the figures reproduced using the iconography

borrowed from comics were given the symbolic names of

Homer, *Cézanne* and *Vermeer*. In 1963, on the other hand, a se-

ries of heroines, *Lolita*, *Lola Cola*, *Roma*, *The Nile Queen*, was

born that looked like certain Hollywood stars as they flung

themselves, smiling, over the austere background of factory

brands, winking ironically with an audacity that is typical of the ad-

vertising world.

Toward the end of the 1960s, Ramos concentrated his efforts on painting

as a technical means of expression. Even though, it is still done with a great

sense of humor, the female nude is now examined in all its physical charac-

teristics. *I Still Get a Thrill When I See Bill*, the series dedicated to De Kooning,

gives us back the vision of an artist who is more interested in pictorial action.

189 Mel Ramos was born in Sacramento on 24 July 1935; he lives in Oakland, California and Horta
de San Juan, Spain.

191 **Virnaburger, 1965**, Wolverhampton Art Gallery, Wolverhampton - Color lithograph - 43.2 x 53.3 cm.

PORTRAIT OF HAWKMAN, 1962

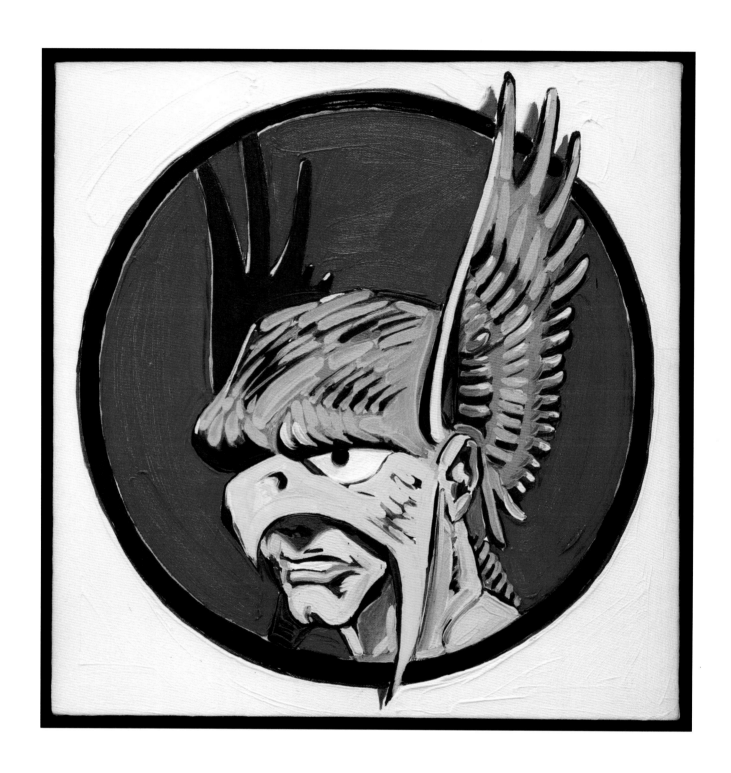

Private Collection
Oil on canvas - 46 x 46 cm

Captain Midnight, 1962

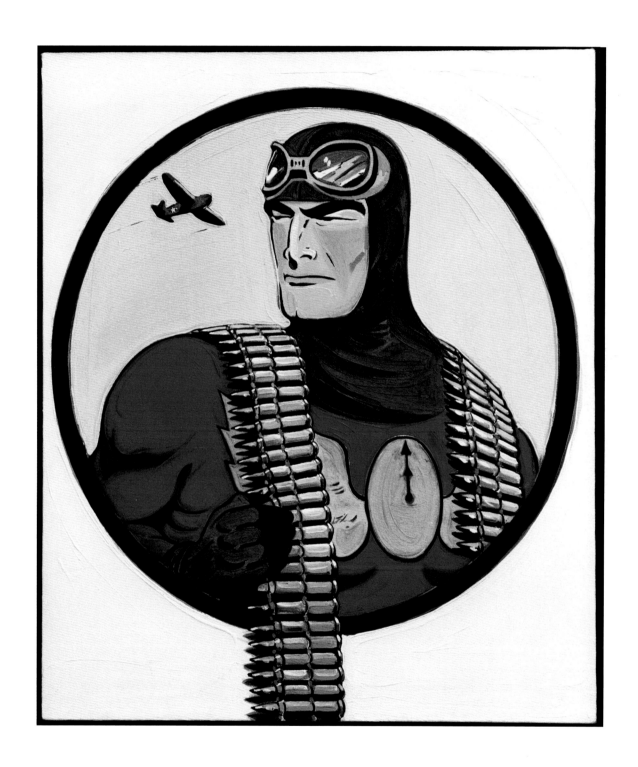

Skot Ramos Collection, San Francisco
Oil on canvas - 81.3 x 66 cm

The Flash, 1962

Private Collection - Oil on canvas - 86.5 x 46 cm

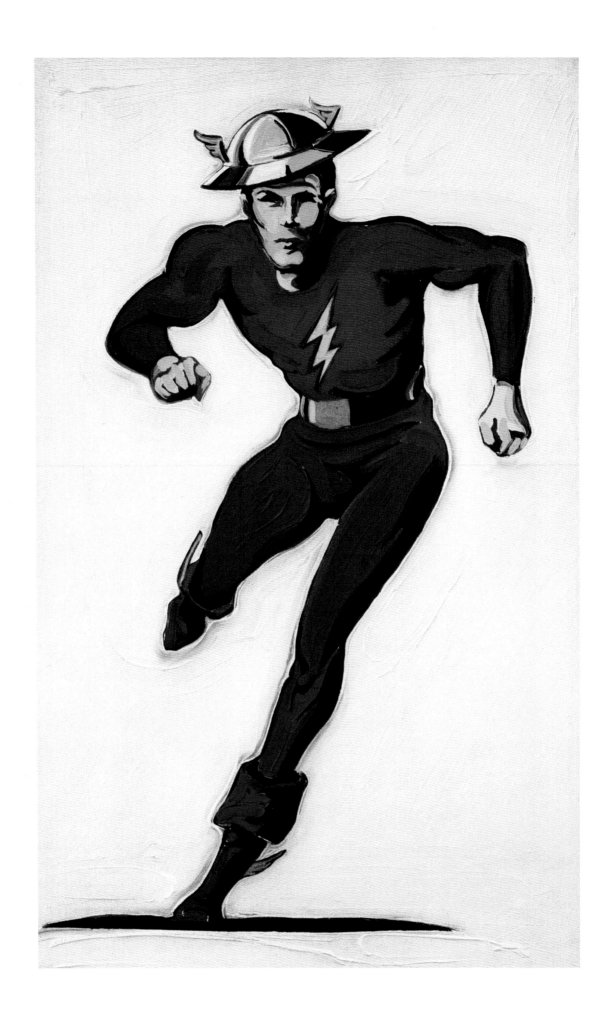

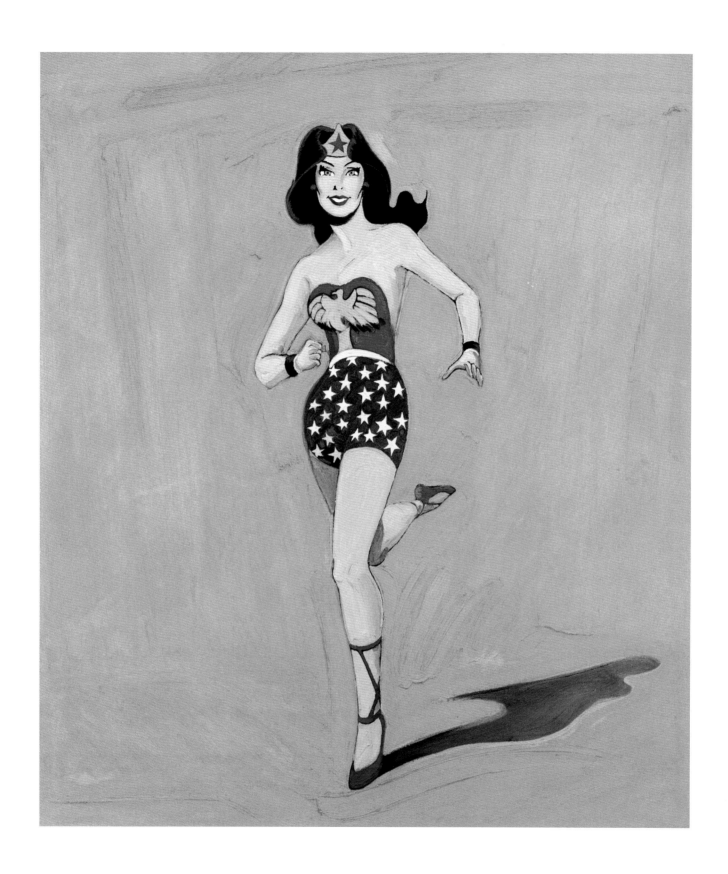

Wonder Woman # I, 1962

Private Collection - Oil on canvas - 127 x 112 cm

LOLITA, 1966

"...It's difficult to get away from this idea
that pop art is what we now think of as pop art.
Pop art was what we called mass media.
Cinema and television; it had
nothing to do with fine art."

Richard Hamilton

In 1956, in the White-chapel Gallery in London, the group exhibition "This Is Tomorrow" was inaugurated. This exhibition brought together a series of environmental projects, with the objective of displaying the imagination of English mass culture, with the use of signs and symbols precisely of those languages which influenced the style of urban life. The English artist Richard Hamilton, who trained at the ICA (Institute of Contemporary Art) with the Independent Group, made a minuscule collage with the title *Just What Is It That Makes Today's Homes So Different, So Appealing?*

It was destined to mark a turning point in European artistic sensitivity. The work gives us a sort of inventory of popular culture: everyday objects, a muscular man, a beautiful naked girl, enclosed in an inhabited interior, steeped in traces of humanity. It is the reflection of a change, a new vision, aimed at representing aspects of society and popular culture which, until that moment, were rejected by the idealist and absolutist art theories.

Richard Hamilton, exponent of photo montage and the juxtaposition of ironic and playful clippings taken from advertising iconography, makes a fundamental contribution to the development of British Pop.

In his work, Hamilton observes the work of Francis Bacon
with admiration. Indeed, Bacon made an important contri-
bution to Pop Art by including in his pictures quoted and
partially modified photography, as documentation of frag-
ments of reality. In Hamilton's work, mass-media culture, con-
sumer objects and the transformation of works of art into merchan-
dise, became the points of departure for a quest based on the neces-
sity to include industrial aesthetics, assimilating some of its aspects.
Obvious Pop references are to be found in *Hommage à Chrysler Corp.*
(1957) which features a car in disguise inside the form of a sensual and erot-
ic female figure. Some years later, Hamilton created *My Marilyn* (1965, pub-
lished 1966), in which he assembled a series of photographs of Marilyn Monroe
published in an English magazine, shortly after her suicide.
His work consisted of a series of painting touches which highlighted some details
of the photographic images.

201 Richard Hamilton was born in London on 24 February 1922; he lives in Oxfordshire, UK.

203 **Just What Is It That Makes Today's Homes So Different, So Appealing?, 1956**
Kunsthalle, Tubingen, Sammlung Prof. Dr. Georg Zundel - Collage - 26 x 25 cm.

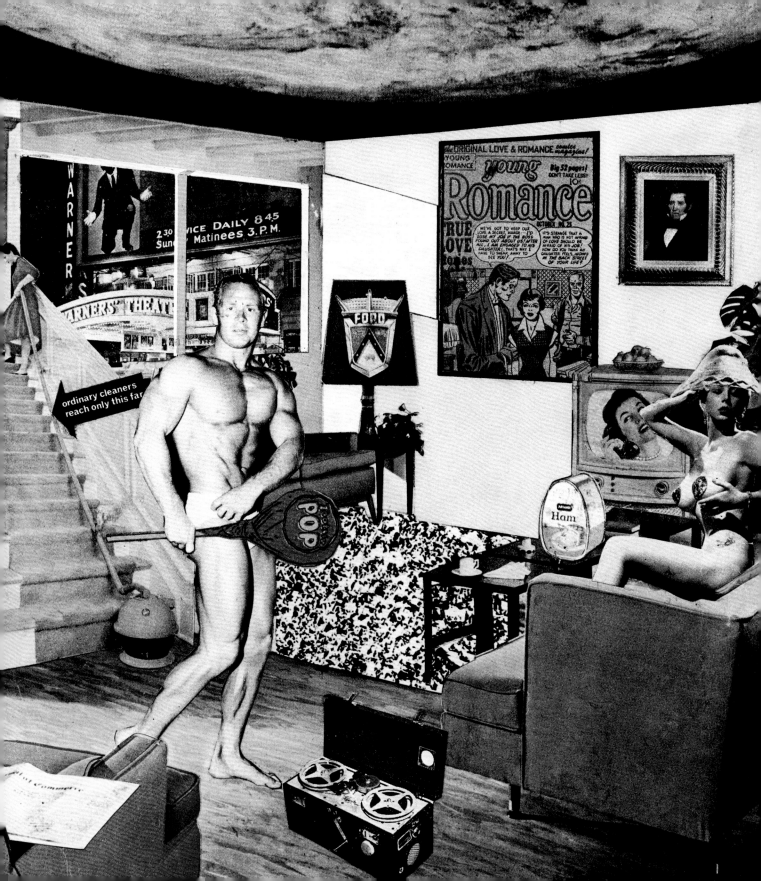

STUDY FOR $HE, 1958

Christie's, London - Crayon, watercolor, bodycolor, pen, brush, and black ink - 31.2 x 24 cm

THE SOLOMON R. GUGGENHEIM
ARCHITECT'S VISUAL, 1965

Museum of Modern Art (MoMa), New York
Crayon, pastel, synthetic polymer paint, and ink on paper - 50.7 x 58.4 cm

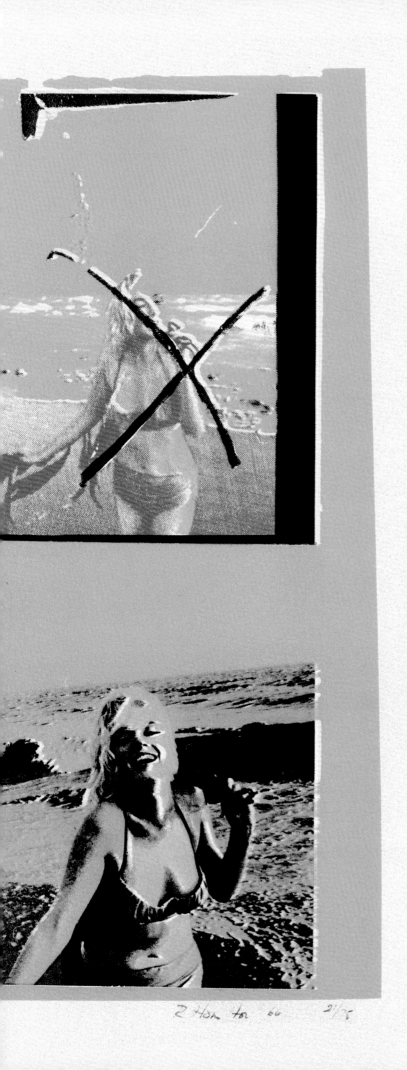

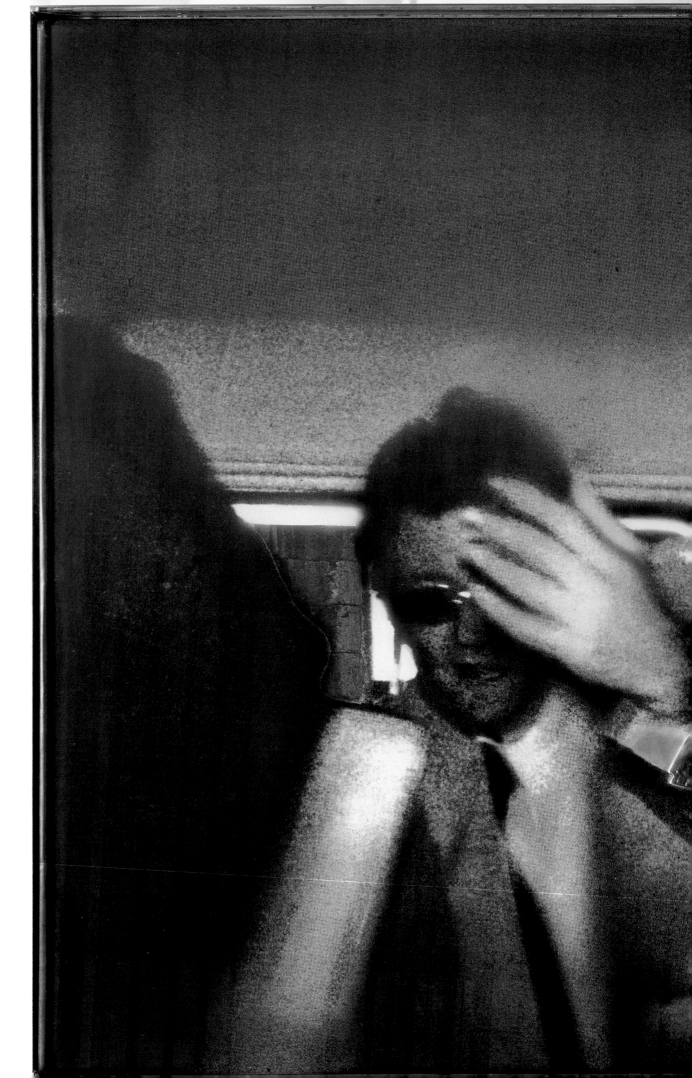

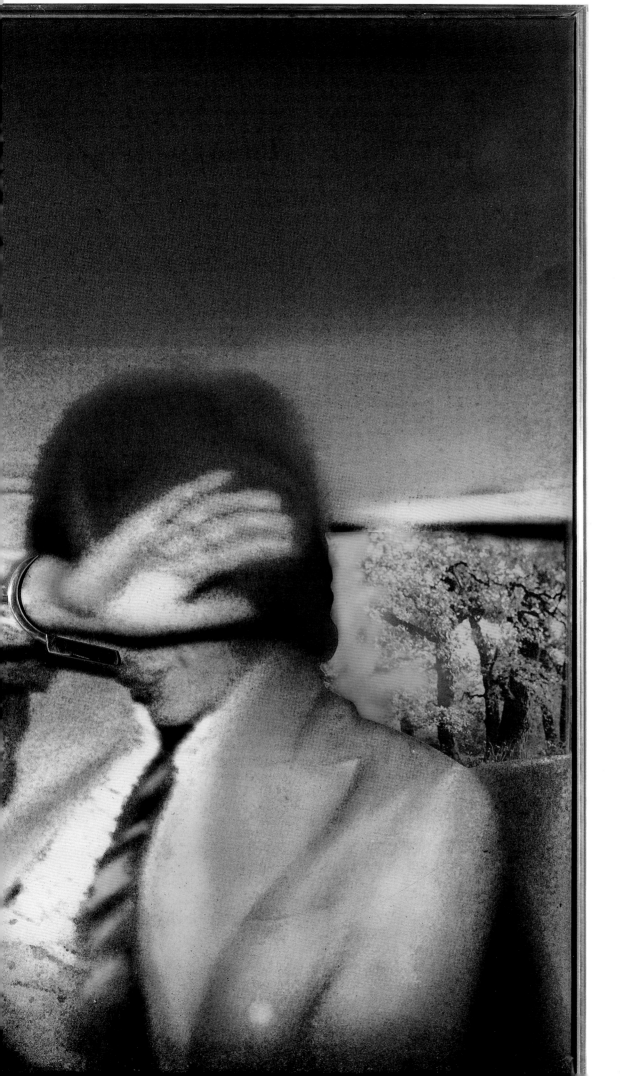

"People say "Why do you paint?,"
and I say "to make magic."
And I think [my paintings]
are making magic."

Peter Blake

The sleeve of the record *Sgt. Pepper's Lonely Hearts Club Band*, one of the most famous Beatles albums, is perhaps Peter Blake's best-known work and a good example of his style, a window looking into a universe overflowing with icons and colors. On the sleeve, next to the four Beatles resplendently costumed in extravagantly colorful old military uniforms, in the middle of a huge crowd of characters, are Marilyn Monroe, Charlie Chaplin, the satanist Aleister Crowley, a boy with a Rolling Stones T-shirt and many, many others. Peter Blake adored Pop Culture, there was no irony in his approach, at most there is a subtle yet revealing humor.

He once said that if his work had a political objective – it was that of making art truly accessible.

He wanted his works to be a visual equivalent of pop music and he hoped that his portrait, *Elvis I* would arouse the same emotions that screaming teenagers experienced during the American star's concerts. It was not easy and indeed he did not succeed. But the importance of this intention must not be underestimated: Blake was one of the artists who represented and lived through the swinging sixties in London, and if it sometimes seems – particularly in his case – that their work was light fun, he nonetheless

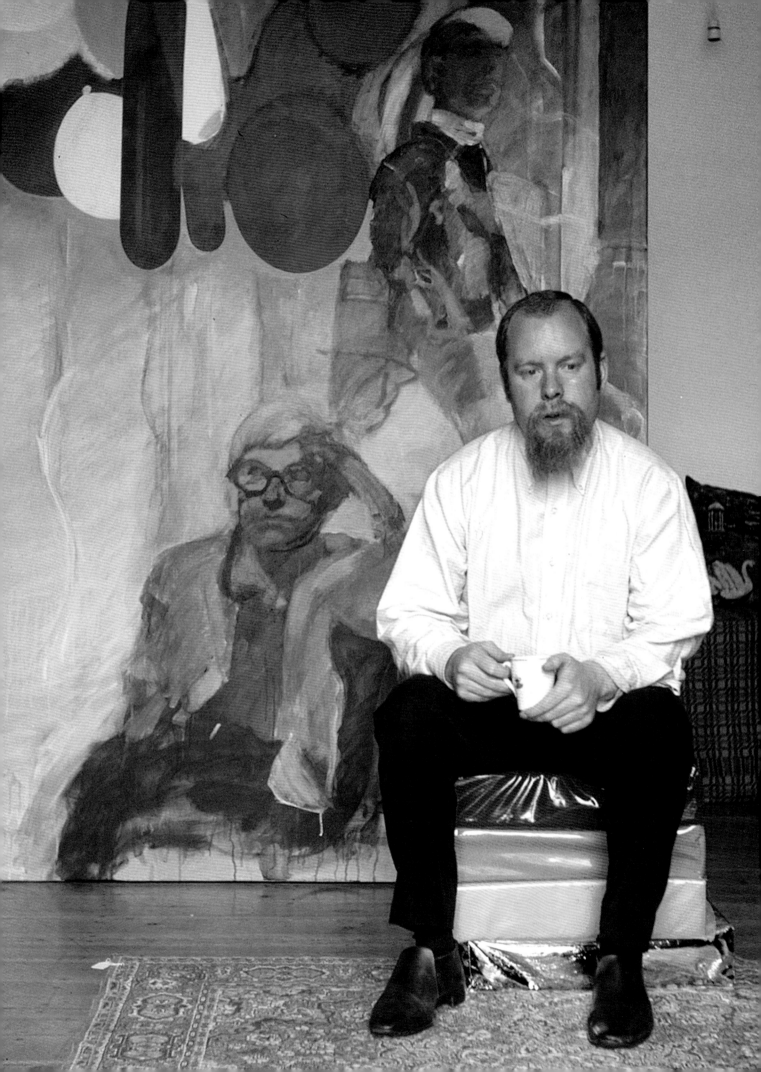

had a central role in the social revolution which was taking place at that time. Mass media and proliferation of signs: Peter Blake explained that as a boy he was excited by the many stimuli he received from discussions with his teachers, who, living in the city, introduced him to art and classical music – just as at home in Dartford, in Kent, he was introduced to wrestling matches, the rhythm of jazz clubs and football.

A myriad of suggestions of different origins which entered, rather noisily, into his art. Peter Blake, in that sense, was a true forerunner. Already in 1952 the circus in Dartford, the games rooms, but also cover girls, appeared in his still immature but important work.

Children Reading Comics (1954) is one of the first pictorial works to really draw attention to comic strips, seven years before Lichtenstein's paintings. The story of Blake, who only subsequently sanctioned bolder techniques and more unashamedly Pop subjects, is a further confirmation that in both England and America, quite independently and in very different ways, there was a need to bring into the art world, a mass culture which was exploding.

A need to be recognized and read, or more simply – Blake did – to make it the protagonist.

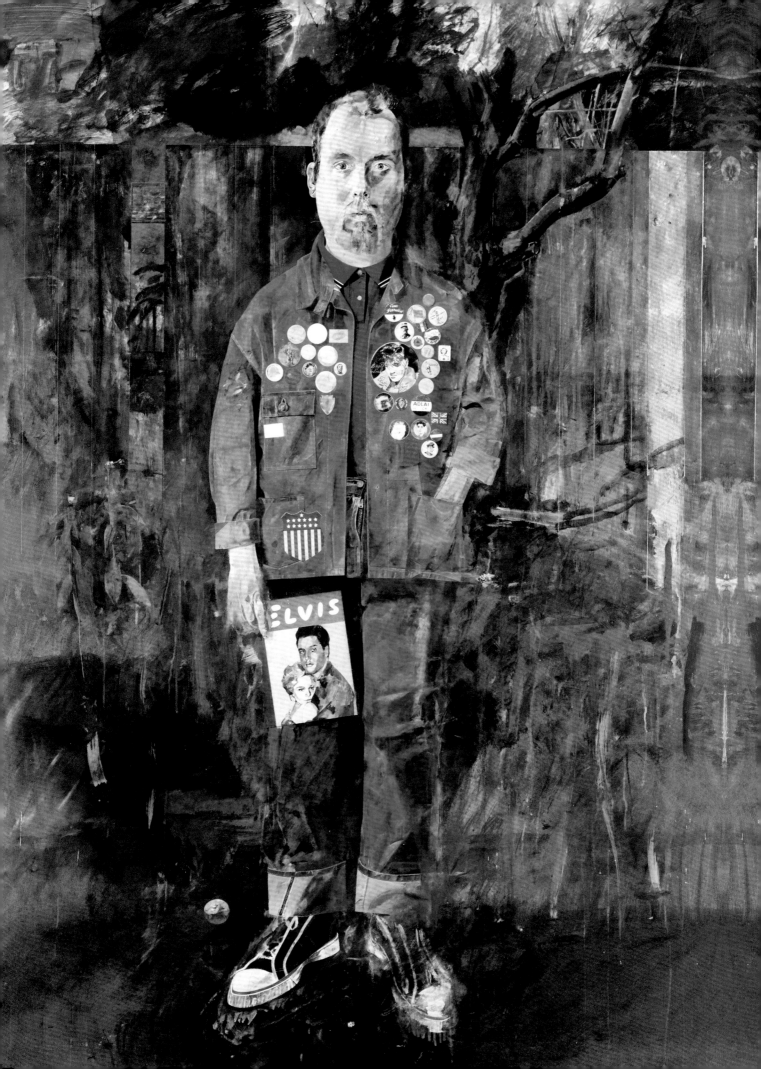

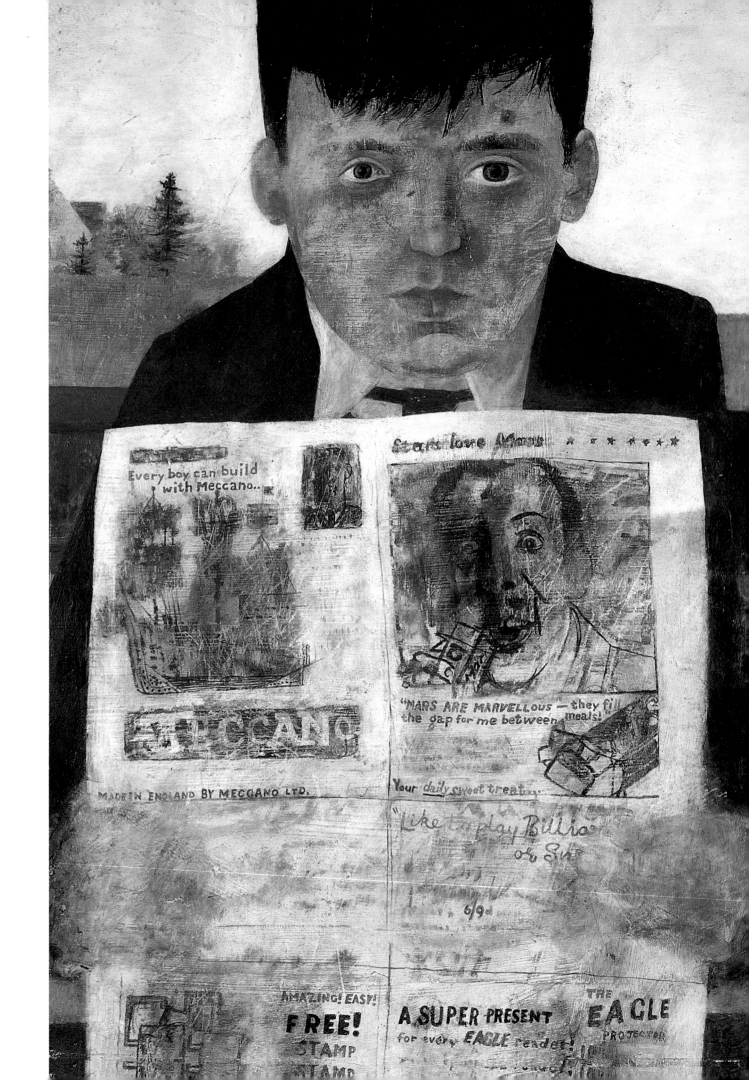

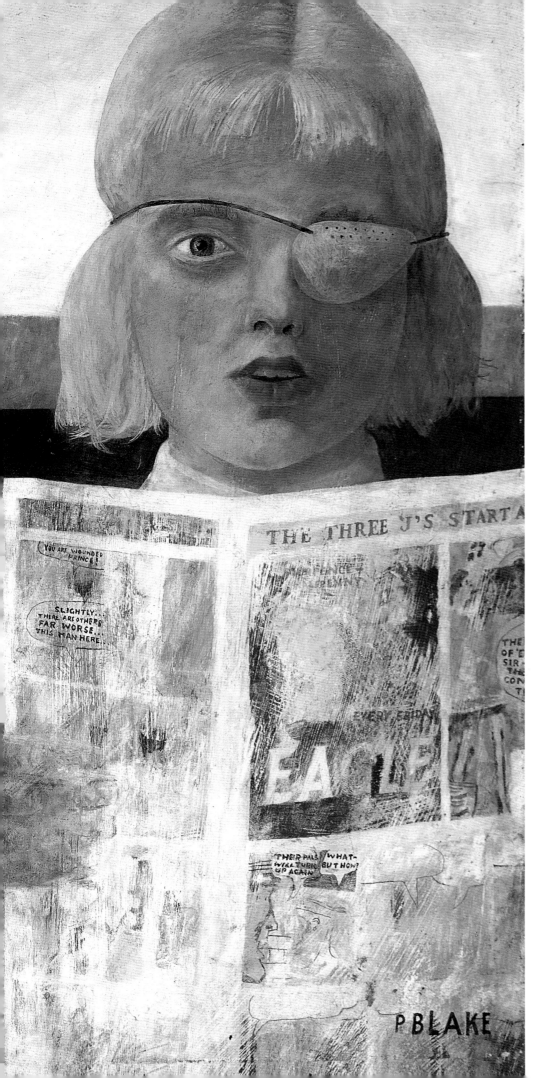

BEACH BOYS, 1964
Tate Gallery, London
Screenprint on paper - 53 x 30.8 cm

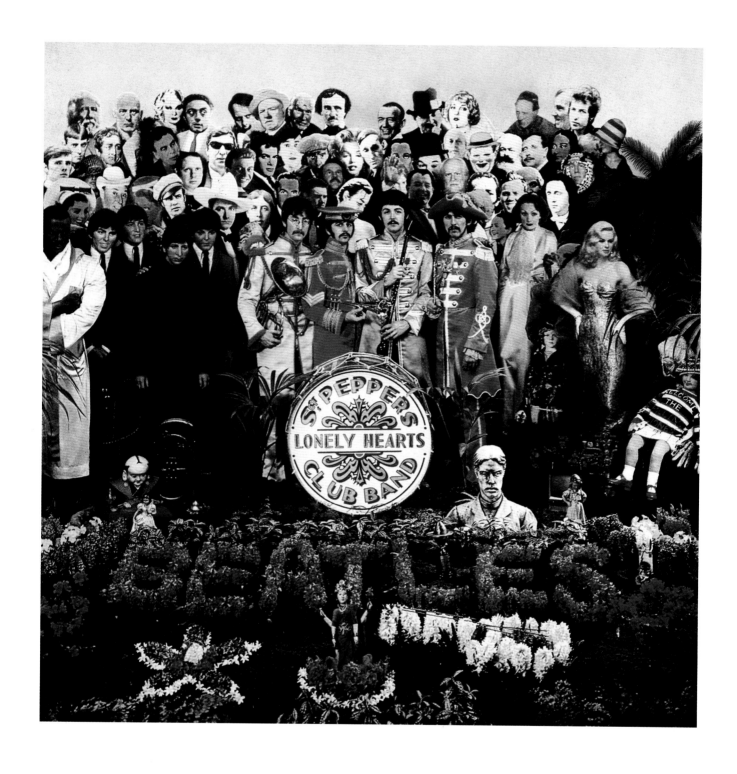

SGT. PEPPER'S LONELY HEARTS CLUB BAND, 1967

Private Collection
Color offset lithograph on paper and paper card - 31.4 x 31.4 cm

Tate Gallery, London - Mixed media, glass and painted wood - 156.8 x 194 x 34 cm

"I really dislike a painting
when it is logical.
It loses its spontaneity..."

Peter Phillips

Peter Phillips was one of the few English artists who gladly accepted the label of Pop artist: wanting to experiment, he impulsively welcomed the advent of new art and lived through the Pop clichés exploring different techniques. He was a student at the Royal College and, younger than his fellow students, at only twenty-one he started to get noticed with *Purple Flag* (1960): clearly inspired by the work of Jasper Johns, this picture was the first indication of the fascination that America and its art would always have for him.

Pop icons, cover girls, from Marilyn Monroe to Brigitte Bardot are already found in his first works. He started by using collage, soon moving away from this technique – which always remained in the background of his work – to oil painting.

It was his time in America from 1964 – living for two years in New York – which led him toward decisively Pop expressive forms: it was here that he encountered the airbrush and began to do screen printing. His aim was to create a picture which lost all obvious signs of manual intervention thus becoming impersonal, anonymous, recalling the idea of serial production and machines.

The surfaces of his pictures became bigger, harder

and brighter and continued to feature mass culture,

which, being decisively skeptical about the behavior of

intellectuals, Peter Phillips used in a thousand different

ways: photographs taken by paparazzi, magazine illustrations,

sexy images, emblems of young culture, elements taken from

gambling tables and funfairs.

It is quite remarkable, that this decisively Pop universe, should

have been associated with pre-Renaissance Italian paintings of reli-

gious inspiration: the artist recognized the resemblance between these

and the design of flipper machines where even his own author's trade-

mark, the five pointed star which appears in many of his works, seems to

be a reference to the halo on the head of the Madonna and the Saints in the

altar-pieces by Giotto and Cimabue.

227 Peter Phillips (right) was born in Birmingham on 21 May 1939; he lives in Europe
and the United States.

229 **Hannibal, 1962**, Private Collection Ink, gouache, and collage - 40.6 x 40.6 cm.

TransORBITALmission, 1968

Tate Gallery, London - Screenprint on paper - 59.1 x 94 cm

TANZANIA, 1970

"The moment you cheat
for the sake of beauty,
you know you're an artist."

David Hockney

Hockney: a young peroxide blond, an English rebel, who became successful when he was still very young – only twenty-five years of age – and became, in a short time, the most important British artist of his time. If English Pop artists were more liberating than their American counterparts, this certainly was the case with David Hockney: at a time when homosexuality, even between consenting adults, was still illegal, his propaganda pictures like *Going to be a Queen for Tonight* (1960), together with some later pictures like *Man Taking a Shower in Beverly Hills* (1964), contributed to creating a more tolerant climate which, in 1967, led to a change in the law.

The homosexuality theme appears repeatedly in his work: as well as being influenced by his own situation, there is also the influence of the work of the gay writer Walt Whitman – whose complete works Hockney read – and his first trip to America, where the New York of 1961, which seemed to him to reflect a brilliant and free society, totally fascinated him.

Once back in England, he drew inspiration from a Warholian approach for the construction of his character and was determined to put himself to the test in painting with an eclectic Picasso-like style: the great originality and ease with which he moves from one style to an-

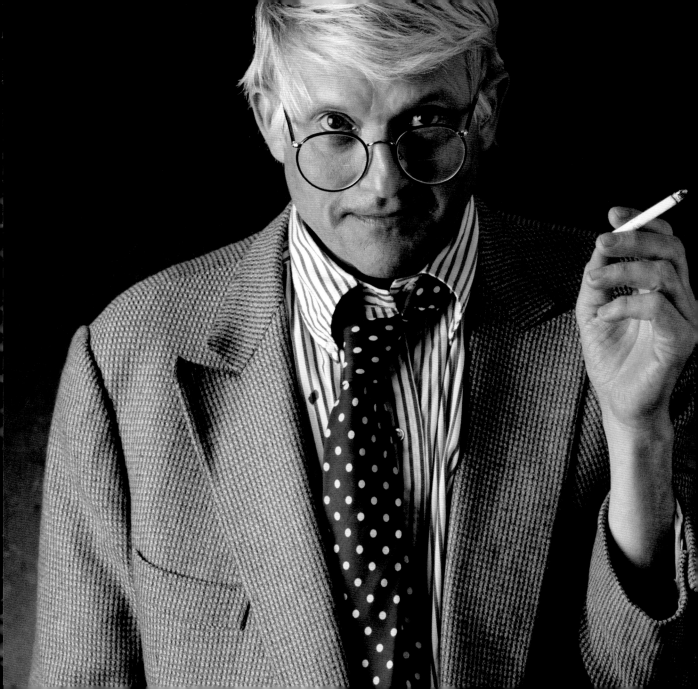

ther, are the key to the success of this artist who never accepted the Pop label. Hockney trained at Bradford College of Art and at the Royal College in London, and had a decisive gift for painting. His big colored canvases seduced everybody. They were permeated by an English sense of humor and a sort of ironic narration which is present in all, at least potentially, of his paintings: in his pictures, amidst the brightness of the acrylics, there are bodies, faces, landscapes and still life which immortalize scenes from the Jet Set world, in almost surreal surroundings. Notwithstanding his enormous success, Hockney left England in 1964 and moved to Los Angeles. The scenes which surrounded him are found in most of his pictures. Naked men around a swimming pool, proliferate in one of his best known series, *Swimming Pool* (1964-67): a portrait of pure Californian pleasure, with its inviting ways, while he lazes around and cultivates the American dream.

237 David Hockney was born in
Bradford (West Yorkshire, UK) on
9 July 1937; he lives in Los Angeles.

238-239 The artist in a curious picture
taken in the mid-80s.

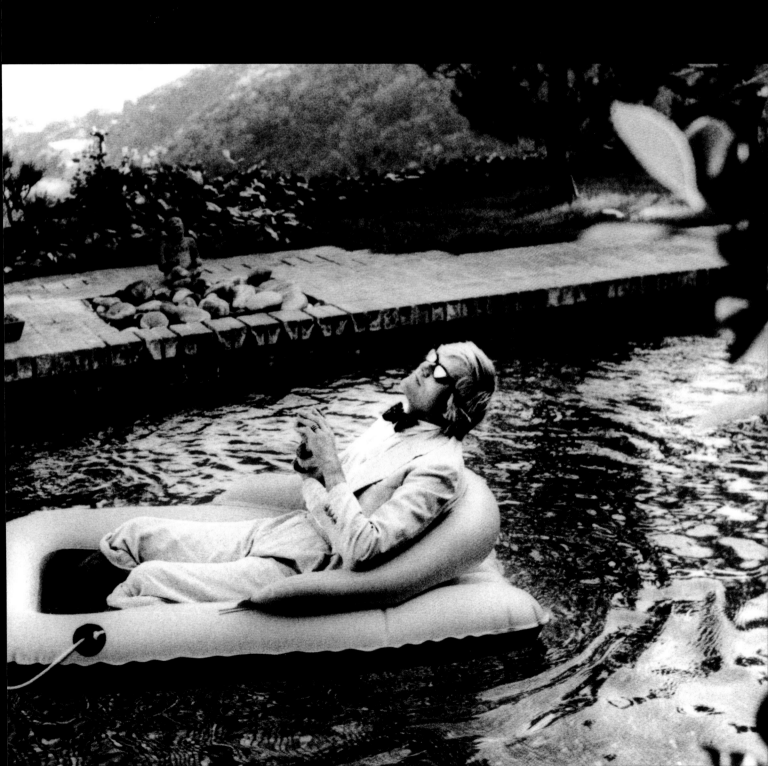

SELF PORTRAIT, 1954

Private Collection - Lithograph in five colors - 29.2 x 26 cm

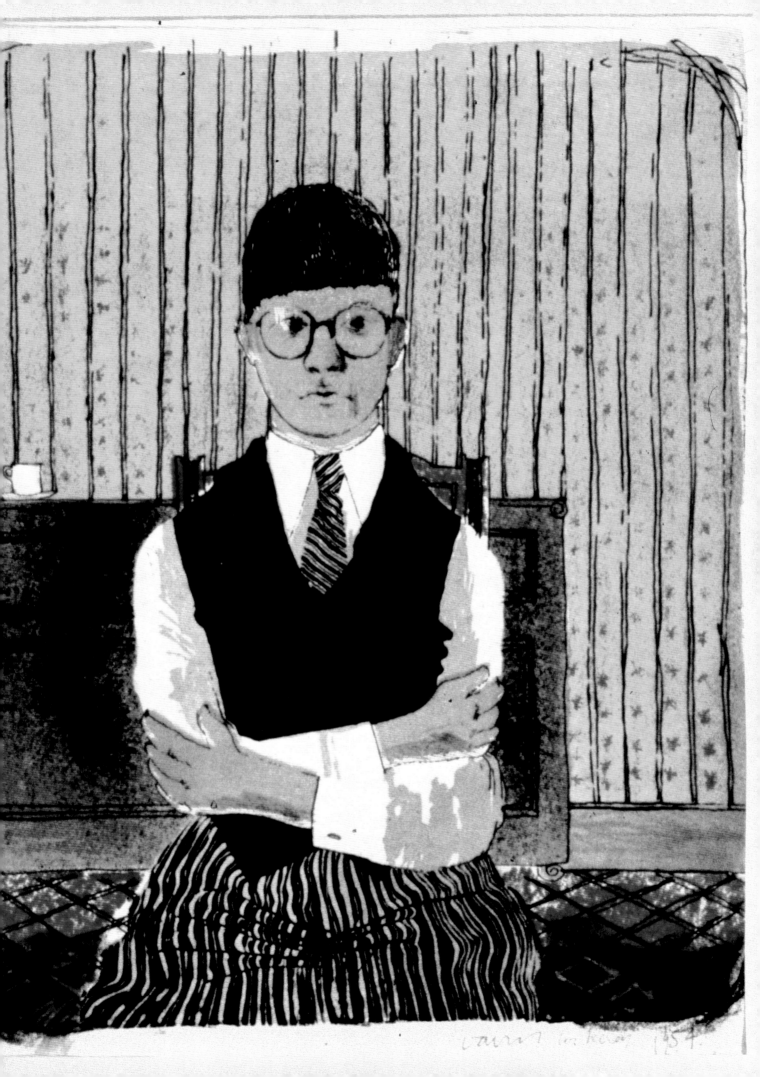

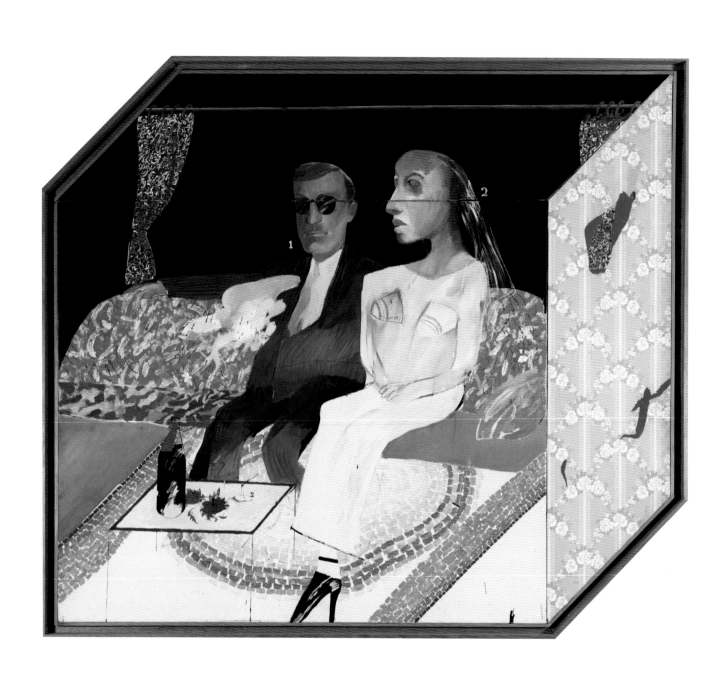

THE SECOND MARRIAGE, 1963

National Gallery of Victoria, Melbourne

Oil, gouache and collage on canvas - 197.5 x 228.6 cm

CLEANING TEETH, EARLY EVENING (10 PM) WII, 1962

Astrup Fearnley Collection, Oslo - Oil on canvas - 183 x 122 cm

BOY ABOUT TO TAKE A SHOWER, 1964

Private Collection - Acrylic on canvas - 91.44 x 91.44 cm

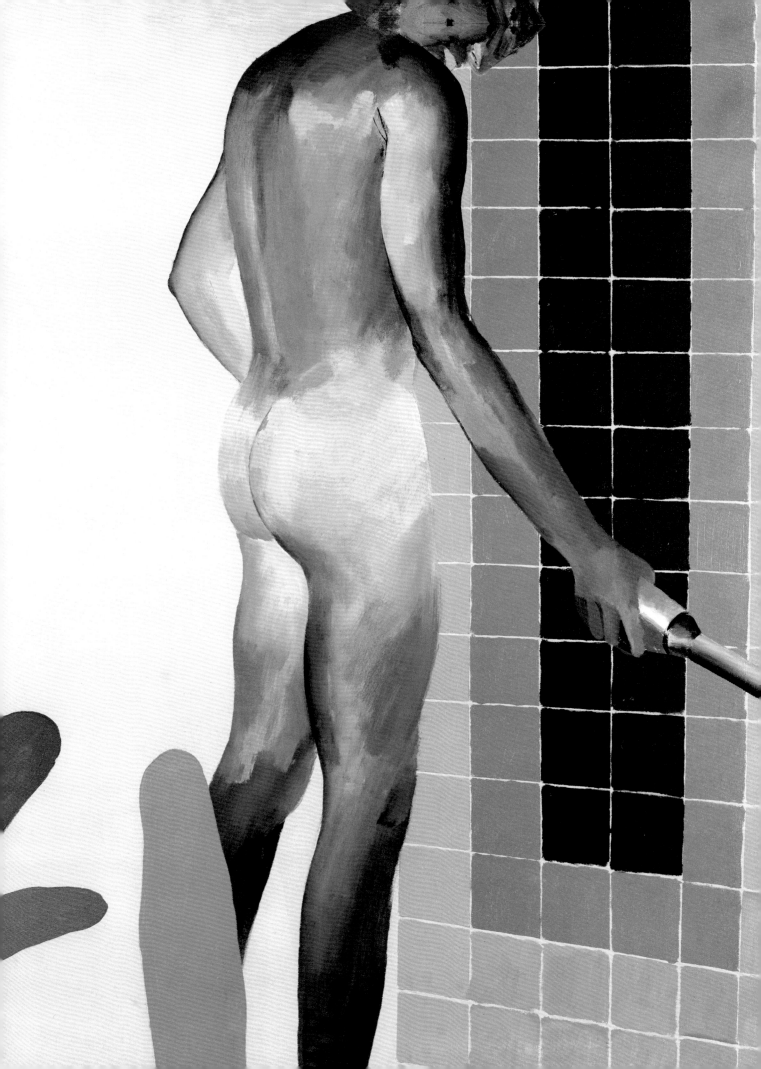

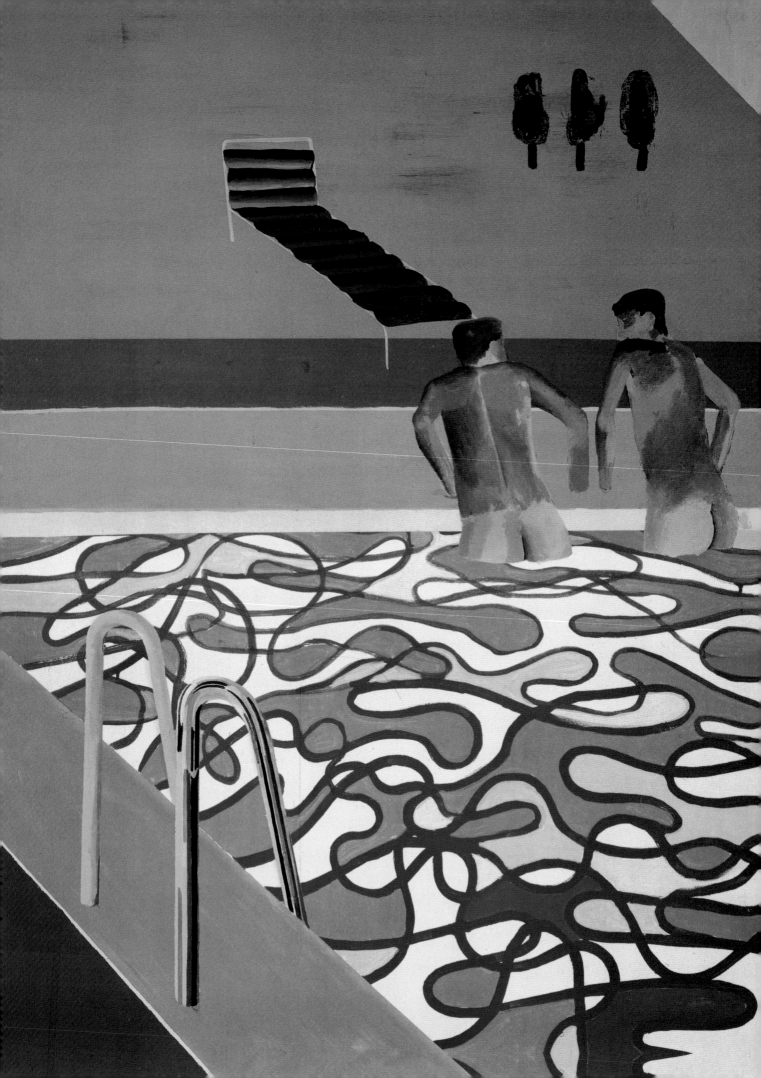

TWO BOYS IN A POOL, HOLLYWOOD, 1965

Private Collection - Acrylic on canvas - 152.4 x 152.4 cm

BEVERLY HILLS HOUSEWIFE, 1966

"Creating messages that are
so of the moment, is almost
a miracle. Ninety percent of
intellectuals do not realize that
Art is a message."

Mimmo Rotella

With Mimmo Rotella, following the postwar years and the early 1950s, Italian art began to open up to the artistic debate which was underway in the United States. And so Italy also moved toward Pop Art, with Rotella and Mario Schifano recognized as the most significant and the most famous exponents. If Andy Warhol remained fascinated by certain images of the new consumer society – the little bottle of Pepsi-Cola, the packets of Brillo pads – in the same way Rotella discovered a wealth of aesthetic material to reinterpret and to violate in cinematographic posters, at that time an advertisement in a class of its own, which were to be seen increasingly both in the squares of little old towns, as well as large cities and in the new suburbia.

Rotella's work seems to concentrate on the object being perishable, on its intrinsic exposure to wear and tear over time, a reflection which led him to invent the poetics of the 'rip' for which the star's face is interrupted by a gash, by a laceration which sometimes acquires ironic and sometimes satiric significance. Rotella, like many European artists of the postwar period, became spokesman for a protest which seemed to be directed against the emerging show business scene.

253 Mimmo Rotella was born in Catanzaro (Calabria) on 7 October 1918 and died in Milan on 8 January 2006.

255 **Objet Trouvé, 1969**
Museo di arte moderna e contemporanea di Trento e Rovereto (MaRT) - Paper on canvas - 111 x 75 cm.

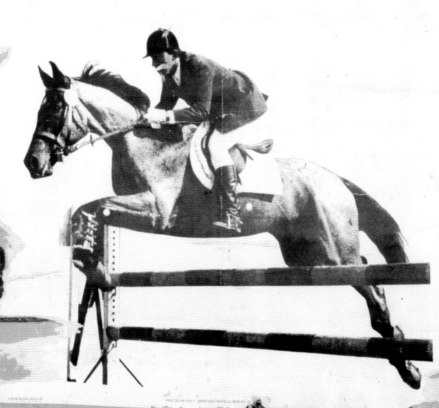

FINALE LIGURE

IX CONCORSO IPPICO NAZIONALE

5-6-7 APRILE 1969

"OBJET TROUVÉ" 1969 - Rotella

SOCIETA' IPPICA FINALESE

PATROCINIO DEL COMUNE DI FINALE LIGURE E DELL'AZIENDA AUTONOMA DI SOGGIORNO

ALE LIGURE 5-6-7 APRILE 19

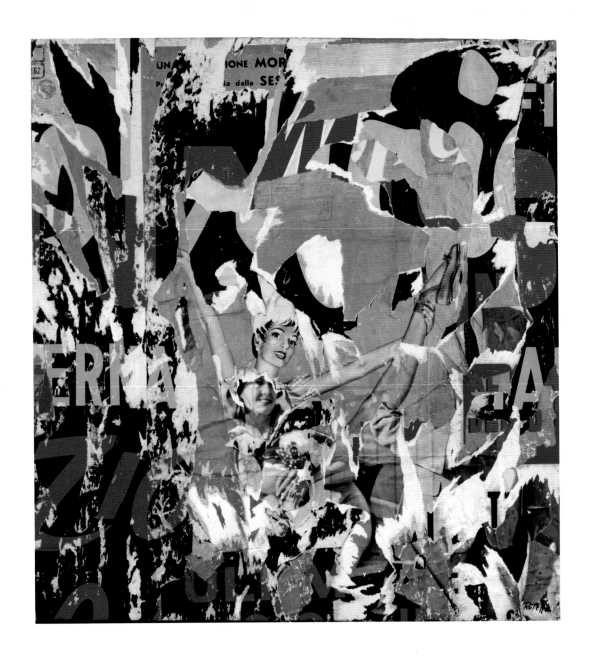

IN MOVIMENTO, 1962

The Tel Aviv Museum of Art, Tel Aviv
Décollage on canvas - 93 x 88 cm

"Culture is like peace:
it is good for everybody."

Mario Schifano

Rome in the 60s. The great artistic vitality triggered off a meaningful dialog in the Italian capital on the most authentic aspects of American Pop Art. Young Italian artists adopted a radical stance, with provocative and absolutist overtones, toward the tradition associated with pictorial representation and the Informal, which was still strong and dominant. This resulted in the elimination of painting or the choice of using only one color, as in the case of Mario Schifano. Schifano associates *Monochrome* with basic stereotypes such as numbers and letters taken from the press and advertising, enlarged and stuck onto white backgrounds full of movement and poetry. The Esso and Coca-Cola brands emerge from elegant backdrops, almost removed from their commercial identity. The school in Piazza del Popolo, headquarters of the Galleria della Tartaruga, frequented by artists such as Tano Festa, Franco Angeli, Giosetta Fioroni along with Schifano, explored the necessity to free stereotypes from their more banal dimension and to treat them therefore, with a wide range of expressive languages. It is not by chance that Schifano is considered the Italian epigon of Andy Warhol.

His research goes beyond purely pictorial boundaries and forcefully invades all aspects of life.

261 Mario Schifano was born in Homs (Libya) on 20 September 1934 and died in Rome on 26 January 1998.

263 **Particolare di esterno, 1962**
Civico Museo d'Arte Contemporanea, Milan
Enamel on paper - 100 x 70 cm.

A short time before Warhol joined the Velvet Underground, Schifano created the avant-garde rock group Le Stelle di Mario Schifano. In the record bearing the same name, which came out at the end of 1967, beat music tracks alternate with long experimental suites. The cover, which had a reddish-purple background on which silver stars stood out, was designed by Schifano.

At the end of the 70s, Schifano, a charismatic, restless and non-conformist character, began to transfer television images directly onto an emulsion-coated canvas, isolating them from the television context of flux and recreating them with touches of nitrocellulose color, giving them a new role. At the same time, he felt the need to abandon painting to enter the world of multimedia: polaroids taken and reproduced on canvas, cinema productions of *Umano non umano, Trapianto, and Consumazione e morte di Franco Brocani*, the result of constant agitated and explosive searching as narrated by his vast artistic production. Luca Ronchi, who was the artist's assistant in the 70s, dedicated a documentary film to him in 2001, *Mario Schifano tutto* (All of Mario Schifano). With regard to the film, the director said: "Perhaps a film about an artist only needs one scene, featuring the protagonist painting. All the rest is superfluous..."

SMALTO SU CARTA, 1963

Rosboch Collection, Rome
Enamel on paper applied on canvas - 160 x 160 cm

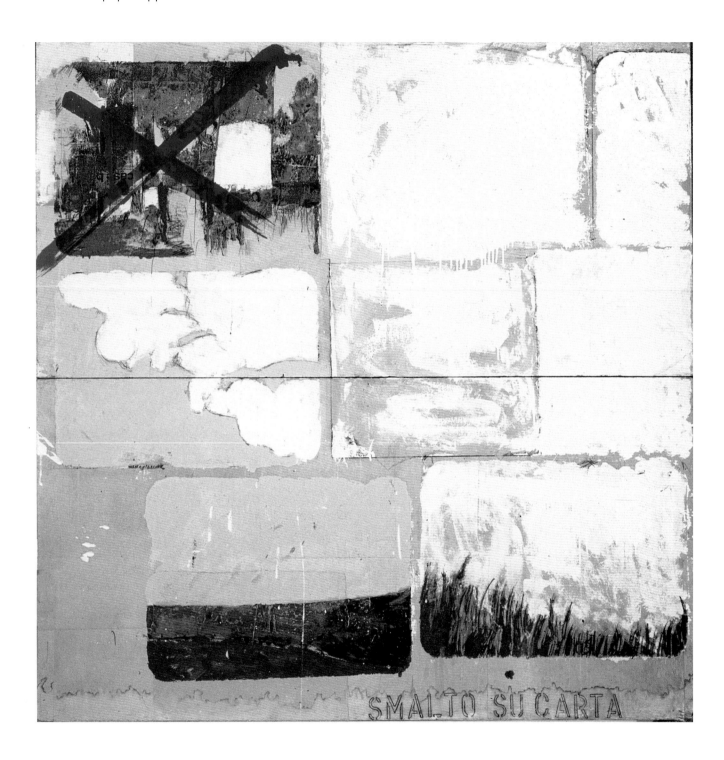

Coca Cola, 1972

Museo di arte moderna e contemporanea di Trento e Rovereto (MaRT)
Acrylic on canvas - 200 x 205.5 cm

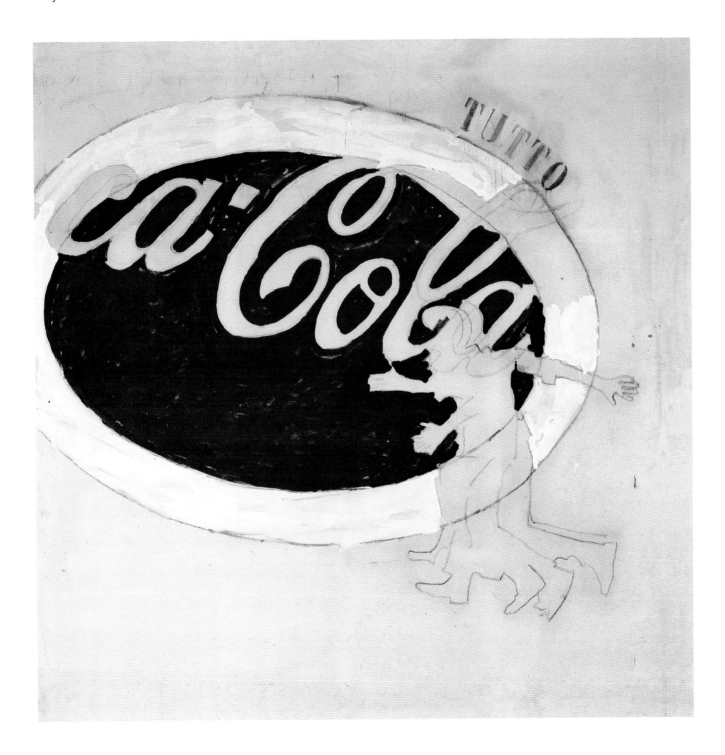

266-267 **Futurismo rivisitato a colori, 1965**
Franchetti Collection, Rome - Enamel on canvas and perspex - 180 x 300 cm.

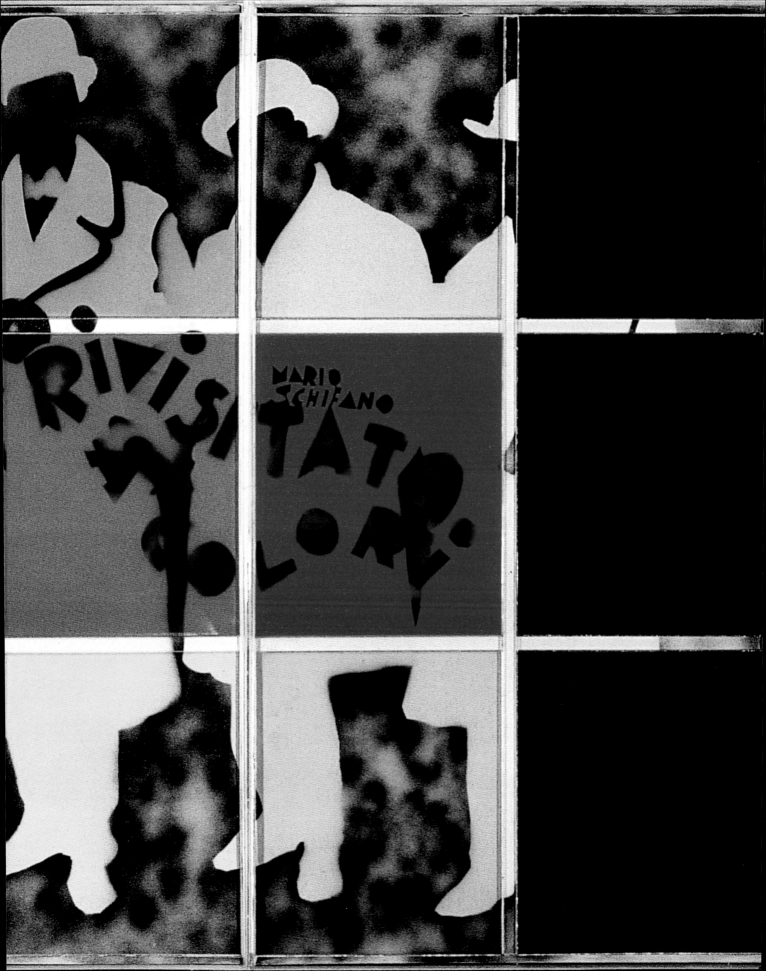

Index

Photo credits

A DAVID & CHARLES BOOK
F&W Media International LTD 2011

David & Charles is an imprint of F&W Media International, LTD
Brunel House, Forde Close, Newton Abbot, TQ12 4PU, UK

F&W Media International, LTD is a subsidiary of F+W Media, Inc., 4700 East Galbraith
Road, Cincinnati OH45236, USA

© White Star Publishers,
Via Candido Sassone, 24
13100 Vercelli, Italia
www.whitestar.it

First published in the UK in 2011

Martina Angelotti, Valentina Ciuffi and Veronica Lenza have asserted their right to be
identified as authors of this work in accordance with the Copyright, Designs and Patents Act, 1988.

A catalogue record for this book is available from the British Library.

ISBN-13: 978-1-4463-0152-4
ISBN-10: 1-4463-0152-4

Printed in China for:
F&W Media International, LTD
Brunel House, Forde Close, Newton Abbot, TQ12 4PU, UK

10 9 8 7 6 5 4 3 2 1

F+W Media publishes high quality books on a wide range of subjects
For more great book ideas visit www.rubooks.co.uk